Seeing
the Gospel

Seeing the Gospel

An Interpretive Guide to Orthodox Icons

EVE TIBBS

Foreword by Richard J. Mouw

Baker Academic
a division of Baker Publishing Group
Grand Rapids, Michigan

Published by Baker Academic
a division of Baker Publishing Group
Grand Rapids, Michigan
BakerAcademic.com

Printed in the United States of America

Library of Congress Cataloging-in-Publication Data
Names: Tibbs, Eve, 1955– author.
Title: Seeing the Gospel : an interpretive guide to Orthodox icons / Eve Tibbs ; foreword by Richard Mouw.
Description: Grand Rapids, Michigan : Baker Academic, a division of Baker Publishing Group, [2025] | Includes bibliographical references and index.
Identifiers: LCCN 2024045298 | ISBN 9781540968005 (paperback) | ISBN 9781493450978 (ebook) | ISBN 9781493450985 (pdf)
Subjects: LCSH: Icons. | Jesus Christ—Iconography. | Christianity and art—Orthodox Eastern Church. | Orthodox Eastern Church—Doctrines.
Classification: LCC BX378.5 .T53 2025 | DDC 246/.53—dc23/eng/20241211
LC record available at https://lccn.loc.gov/2024045298

Cover art provided by Uncut Mountain Supply. Cover design by Paula Gibson.

Baker Publishing Group publications use paper produced from sustainable forestry practices and postconsumer waste whenever possible.

25 26 27 28 29 30 31 7 6 5 4 3 2 1

For Steve, our daughters, and their families:
Jason, Jennifer, James, and Jonathan,
Father Angelo, Presvytera Mary, Andreas, Stephen, and Evfemia,
Derick, Andrea, Nicholas, Eleni, and Emilia.

"We love because He first loved us."
1 John 4:19

CONTENTS

FOREWORD

Richard J. Mouw

Eve Tibbs says that she wrote this book as an "open invitation" for readers to join her in discovering "the layers of meaning waiting to be discovered within the depths of Orthodox icons." As I began to read her insightful discussion, though, I thought of myself as being hosted at a splendid Orthodox feast.

I borrow that feast image from the great Orthodox theologian Alexander Schmemann. Eve and I once spoke, during her student days at Fuller Seminary, of our mutual admiration for Father Schmemann's wonderful writings, but in this case my memory of his use of the feast image was not from something he had written but from a comment that I actually heard him make in New York in the 1970s, at a group meeting to plan an ecumenical consultation. I had been with Father Schmemann a couple of times before, and I had always been appropriately impressed by being in his wise presence. This time, though, he was in a grumpy mood, as became obvious when he was asked if he was willing to be one of the speakers at the event we were planning—"to contribute some Orthodox thoughts?" He grumbled in response that, yes, he would do it, but he was tired of being asked to bring an Orthodox casserole to an ecumenical potluck.

"Sometime," he said, "we would like you folks to be willing to let us host you at a full a Orthodox banquet!"

Reading this book has provided me with the culinary experience that Father Schmemann had in mind. I confess that my own explorations in Orthodoxy have typically been of the potluck variety: sampling specific topics in soteriology, ecclesiology, eschatology—as well as spending time with Orthodox friends. But reading this book is my first time in thinking for more than a few minutes about icons.

It has been a delightfully satisfying meal, and I know that I will want to keep returning to the table. Eve emphasizes how icons enable us to "see the gospel" in new ways, and she certainly did that for me. My evangelicalism has conditioned me to rely on texts—chiefly the pages of the Bible itself, along with hearing sermons and reading commentaries about those texts. While I have often been inspired by visual depictions of biblical scenes, I haven't expected them to expand my theological understanding of the gospel.

The icons that Eve chose to show us in this book have instructed me on what I have been missing. I'll offer one example: the icons portraying Nativity scenes. A Catholic friend once told me about the spiritual benefits she derived during Advent from the practice of "contemplating the infant Jesus," and while her brief explanation intrigued me, I did not make much of an effort to follow through. Eve has now helped me see what I have been missing. She shows how and why Orthodox art has rejected the depiction of the manger in an "A-frame" setting in favor of a cave venue. That the baby in swaddling clothes can also be seen as lying in a tomb, wrapped in graveclothes, is not meant to convey a morbid image. This is an example of an anticipatory "layer of meaning" between Gospel events: The joy of the Savior's birth anticipates the joy of His resurrection.

One impressive theological lesson that I learned from Eve's discussion of Nativity icons is why Orthodoxy rejects the "Holy Family" scenario that is so common in Western art (and also on our Christmas cards). In the Orthodox icons, Joseph is often depicted as older than we are accustomed to, and he is sitting or standing some distance

from the mother and child. This is meant to highlight the fact that he is not the actual father of the Christ Child. The common family image of a human husband and wife sitting contentedly with a baby in a manger fosters sentiments that detract from the supernatural mystery of the Savior's advent.

I want those examples to serve as my invitation to others to learn much-needed lessons that Eve provides for "seeing the gospel" in new ways and to discern "layers of meaning" between Gospel events. Or, to repeat Father Schmemann's image, after reading this wonderful book, we will never again be content to sample the occasional Orthodox dish at a potluck!

PREFACE

Orthodox Icons: "More Than Meets the Eye!"

The phrase "more than meets the eye" kept following me as I thought about how to preface what I hope to convey in this book about Eastern Orthodox **icons**.[1] I realize that more than anything, I really want Western Christian readers to understand that something exciting awaits in this investigation. Icons are indeed much more than what one might realize at first glance. It is not an overstatement to suggest that learning how to read an icon offers an opportunity to engage Holy Scripture with greater depth and understanding, by revealing dimensions and facets that can yield fresh insights. The icon literally offers the difference between seeing something in "black and white" versus "in living color," and yet it offers even more than that—it offers an encounter with the **Kingdom of God** from within the created world.

Icons not only inhabit Orthodox churches but also may be found in every room of an Orthodox Christian home, hanging on walls or sitting on nightstands and shelves—and outside the home, in offices

1. Terms defined in the glossary are set in boldface when they first appear in the book.

and even in cars. The Icon of the Hospitality of Abraham and Sarah, for example, hangs in our kitchen, and the Icon of the Mystical Supper is displayed on a stand at our dining table. Icons of our patron saints Stephen and Paraskevè hang next to the Icon of **Christ** at our family altar. And as I write this, I contemplate a beautiful Icon of Jesus at my desk—a copy of the one painted by the hand of the fifteenth-century Saint Andrei Rublev. It was presented to me by my parish at the completion of my first graduate degree in theology. Christ's serene gaze offers both the consolation of His great mercy and a reminder that my work is an offering to Him. In plain fact, icons fill the world that Eastern Orthodox Christians inhabit with meaning and, above all, with presence.

I clearly have a deep personal, devotional, and spiritual connection to Orthodox icons. However, this book does not in any way focus on the practice of praying with icons or on personal spirituality. It is an academic text that explores the interpretation of scriptural meaning depicted in icons. To present this subject in a structured and scholarly manner, I have set aside my personal attachment to it. This transition has not been without challenges. I have sought balance in conveying the intellectual aspects of interpreting icons while also capturing the spiritual essence that resonates from their core. Hopefully, I have not strayed too far into the "head" and away from the "heart." If my writing falls short of reflecting the beauty of God's Kingdom as made present in icons, it reveals my limitations rather than those of the icons themselves.

In my Greek Orthodox ecclesial context, I have served as a ministry lead in Christian education for many decades. I include icons at every Bible study, at every retreat and seminar, and at every theology class. I have been invited to offer formal lectures on Orthodox icons in both Orthodox and Protestant church settings. In order to speak somewhat authoritatively about the meaning of icons on these occasions, I have read both academic and devotional books on icons. I have searched websites for answers to questions about specific **iconographic** themes or **attributes**. I have spoken with those who have a

divine call to create icons and with those who have been called to be caretakers of icons. I was especially honored to have spent a day as the driver of Father Justin, the head librarian and archivist of Saint Catherine's Monastery in Sinai, Egypt, on one of his visits to the United States. The library of Saint Catherine's Monastery houses half of all the Byzantine-era icons that have survived to this day.[2] Through all of this, I realize now that I have come to internalize the message of icons in a way that no longer points to specific sources of information. Yet many superb books on icons have influenced this work, and I have listed them together in a select bibliography for the reader seeking to investigate further.

In my capacity as a professor of systematic and historical theology at Fuller Theological Seminary, a diverse evangelical graduate school, I am aware of the unfamiliarity many evangelical Christians, including seminarians, have with Orthodox Christianity. The development of an introductory course on Eastern Orthodox theology at Fuller prompted the creation of my book, *A Basic Guide to Eastern Orthodox Theology: Introducing Beliefs and Practices*. For readers of this current book who may also be new to the theology and practices of Eastern Orthodox Christianity, *A Basic Guide to Eastern Orthodox Theology* can serve as a valuable introduction to the topic.

This present book, however, is less textbook and more an open invitation. I extend a warm welcome to readers to accompany me on a spiritual odyssey to uncover the unique "more than meets the eye"— the layers of meaning waiting to be discovered within the depths of Orthodox icons.

2. I am also grateful to Fr. Justin, who on behalf of the monastery granted permission to use the image of the sixth-century Icon of the Nativity in this book.

ACKNOWLEDGMENTS

Glory to God for all things!
—Saint John Chrysostom[1]

First and foremost, I offer all glory to God for the many blessings that have accompanied this journey—the love and support of family and friends, the guidance of wise pastors and teachers, and the privilege of contributing to such a meaningful project.

I am deeply grateful to Dr. Richard Mouw for generously providing the foreword to this book. His writings and teachings have challenged and uplifted many scholars across the Christian world, and his distinguished leadership at Fuller Theological Seminary has been a source of inspiration to me and countless others. It is a privilege to have his voice introduce these pages.

I would like to thank Robert Hosack for his support in bringing this unique project to life and the entire superb team of professionals

1. "Glory to God for all things" were the final words of the golden-mouthed preacher Saint John Chrysostom as he departed this life while in exile in the fifth century, in what is now modern-day Turkey. It is a profound expression of gratitude and praise to God for all aspects of life, both joyful and sorrowful.

at Baker Academic for their invaluable insights and assistance through this process. Thanks also to my friends and early readers Maria Conley and Nicholas Bundra.

The icons in this book have come to these pages from many sources, spanning centuries and continents. I am especially indebted to the contemporary iconographers who have entrusted me to describe the icons created by their hands for the glory of God: Paul Akzoul, Tom Clark, Michael Kapeluck, Dmitry Shkolnik, and Father Tom Tsagalakis. Many thanks also to the family of **iconographer** Diamantis John Cassis, of blessed memory, for sharing two of his beautiful icons.

Some of the icons featured here were photographed in Orthodox churches and chapels throughout the US especially for this book. I extend my gratitude to the talented photographers whose images grace these pages: Allen Altchech, Father Ted Bobosh, Father Stephen Callos, Denise Canellos, Alex Gorbenko, Jacqueline Lovato, Father Angelo Maginas, and Megan Papachristou.

Finally, I give glory to God with a heart full of gratitude for my family, whose love and support are my greatest blessings. To my wise, kind, and loving husband, Steve, and our wonderful daughters, Jennifer, Presvytera Mary, and Andrea, and their husbands, Jason, Father Angelo, and Derick—thank you for your endless patience and encouragement. To our precious grandchildren, James, Jonathan, Andreas, Stephen, Evfemia, Nicholas, Eleni, and Emilia—you each bring a special joy to our lives, and being your *Yiayia* is an honor and a gift.

Paraskevè (Eve) Tibbs
September 1, 2024
Feast of the New Ecclesiastical Year

INTRODUCTION

Pictures of People We Love

By way of introduction, I would like to share a story about the only grandparent I knew, my *yiayia* Paraskevè, and our patron saint, Paraskevè of Rome. I possess only a few photos of my *yiayia*, who was born in late nineteenth-century Greece, and they hold great significance to me. When I see her smiling eyes in those photographs, I am transported back to the cherished time I spent with her when I was a young child. These photos serve as powerful reminders of her boundless generosity, infectious sense of humor, unwavering Christian faith, and especially the love and care she showed me and my sisters. I cherish those photographs because of what she still means to me. Icons, like photographs, are pictures of people we love, preserving their memory and allowing us to connect with their presence.

My given name in Greek is also Paraskevè. As her only namesake, I inherited my *yiayia*'s nineteenth-century painted icon of Saint Paraskevè of Rome, a second-century Christian Great Martyr. The term "Great Martyr" is a designation given to individuals who endured severe and brutal tortures for their faith in Jesus Christ. Paraskevè was arrested and tortured for refusing to deny her Christian Faith and worship idols. She was ultimately beheaded around AD 160, but

her unwavering devotion and witness to Jesus Christ brought many to Christianity.[1]

While I treasure that icon of Saint Paraskevè, its significance goes far beyond its age and association with my beloved grandmother. My attachment to that icon stems from the profound honor and affection I hold for Saint Paraskevè herself. She was a strong and faithful Christian who refused to deny Jesus Christ despite suffering unspeakable horrors. Very simply, the love and reverence that Orthodox Christians, like me, have for icons of Jesus Christ and His righteous followers can be attributed to our deep affection and reverence for the individuals depicted in them.

A Visual Biblical Language for a Visual Culture

In the twenty-first century, we are witnessing the widespread rise of a visually driven culture. Visual media and various forms of visual communication are becoming increasingly pervasive, eclipsing the written word in many parts of society. A large segment of the population now turns to video streams for their daily news and information about the world, shifting away from traditional sources such as books and newspapers. The power of visual content cannot be ignored. In fact, this book was written with the intention of attracting the interest of visually oriented contemporary Christians.

Images permeate our daily lives today, but a treasure trove of sacred art has captivated Orthodox Christians for centuries. This book invites readers on a journey of exploration into the visual biblical world of the icon. As readers delve into the content of this book, it will become evident that Orthodox icons communicate from a rich biblical foundation in a unique visual language. It is a

1. Nikolai Velimirović, *The Prologue of Ohrid: Lives of Saints, Hymns, Reflections and Homilies for Every Day of the Year*, vol. 2 (Alhambra, CA: Serbian Orthodox Diocese of Western America, 2002), 105. Some sources give AD 140 and others AD 180 as the year Paraskevè entered eternal life. The Prologue simply says, "She suffered honorably for Christ in the second century."

language worth learning to further both understanding and spiritual enrichment.

The contemporary visual culture has brought many benefits but also a few unfortunate consequences, one of which is the decline in general literacy skills. The past few decades have also seen a significant decrease in Bible literacy. The American Bible Society's annual *State of the Bible* report indicates that in 2024 only 38 percent of Americans are "Bible Users" who read the Bible three or more times per year on their own outside of church.[2] One of the most respected preachers and biblical commentators of the Patristic era was Saint John Chrysostom (347–407), who taught that "ignorance of the Scriptures is a great precipice and a deep gulf; to know nothing of the Scriptures, is great betrayal of our salvation."[3]

Whether readers are already familiar with icons or new to this ancient tradition, my desire is to rekindle interest in the written **gospel** while cultivating an appreciation for the visual narrative of the Bible expressed in Orthodox icons.[4] Ultimately, my hope is that through this exploration, we may all draw closer to Jesus Christ Himself.

The Icons: Old and New, Near and Far

Many Orthodox Christians regard icons with profound devotion. Following the early twentieth-century Bolshevik Revolution in Russia, when the new Soviet Union began closing and destroying churches and persecuting Christianity, Orthodox Christians literally buried

2. American Bible Society, *State of the Bible USA 2024*, September 2024, https://1s712.americanbible.org/state-of-the-bible/stateofthebible/State_of_the_bible-2024.pdf. This statistic raises cause for concern, considering that 68 percent of Americans identify with Christianity, according to 2023 polling by the Gallup organization: Gallup, "How Religious Are Americans?," March 29, 2024, https://news.gallup.com/poll/358364/religious-americans.aspx.

3. John Chrysostom, "Discourse 3," in *Four Discourses of Chrysostom, Chiefly on the Parable of the Rich Man and Lazarus*, trans. F. Allen (London: Longmans, Green, Reader, and Dyer, 1869), 67–68.

4. Terms defined in the glossary are set in boldface when they first appear in the book.

their icons rather than see them destroyed by the atheist state. After Christianity again became legal there, the icons were unearthed and restored to their proper places in homes and in churches. When the Yaroslavl Art Museum was moving to a new building in 1977, workers there discovered eighty icons buried under a layer of dirt at the location.[5] I mention this because two of the older Russian icons I have chosen for this book were restored from under that very museum!

I have included both ancient and contemporary icons depicting the same events to show the thematic consistency of portrayals across many centuries. Most of the ancient icons are in the Byzantine style, either from Greece or from Russia. Contemporary one-panel painted icons are listed as being "by the hand" of Orthodox iconographers based in the United States. Icons are typically handed down through the generations of Orthodox Christian families, or they are given to new caretakers. As I was finalizing the list of icons for this book, my friend Denise sent me a photo of a very old icon of Jesus Christ that she adopted in this way (see fig. 3.6). The icon now resides in her living room. I agreed with Denise that the colors used and the sweet face are very striking, so I have included it in chapter 3. The mosaic murals were photographed in my home parish in Irvine, which hosts a stunning array of wall-to-wall and floor-to-ceiling icons of the life of Christ. Also included are contemporary painted murals (**frescoes**) photographed in four other Orthodox churches and one Orthodox chapel in the United States.

The Audience

In the courses I teach at Fuller Theological Seminary in Southern California, I typically begin each class session with a Scripture devotion. I will occasionally incorporate icons from my Eastern Orthodox background that correspond to specific events described in the Bible.

5. "Destruction of Icons," The Museum of Russian Art, https://tmora.org/online -exhibitions/transcendent-art-icons-from-yaroslavl-russia/introduction-yaroslavl-city -of-the-bear/destruction-of-icons/.

As a result, I have experienced firsthand how Orthodox icons may seem strange at first to Christians outside of the Orthodox Church. And yet, after explaining the symbolism and meaning behind these icons, I have also often witnessed a discernible "aha moment" of recognition and appreciation from my students.

In the pages that follow, I aim similarly to cultivate within readers a deeper understanding and appreciation for icons—irrespective of their prior exposure to them. Delving into the layers of meaning that Orthodox icons carry can be an enriching pursuit, inviting Christians in all traditions to embark on a transformative journey of faith and contemplation.

An Exegetical Approach

This book serves as an interpretive guide to seeing the gospel in Orthodox icons. Biblical scholars refer to the careful analysis and interpretation of the Bible as "**exegesis**." The same term may be applied to uncovering the meaning of the visual language of Orthodox icons to reveal deeper layers of understanding of the gospel message. Thus, the icon itself serves as an **exegetical** tool that can enhance and illumine the textual message of the Bible.

Due to the close correspondence between the written Scripture of the four Gospels and the visual representation found in Orthodox icons, a careful analysis of one can lead to the discovery of new dimensions of meaning in the other. Interpretation between text and image therefore operates in a reciprocal manner within the context of this book.

How This Book Should Be Read

Part 1 of this book lays a broad foundation for the study of Orthodox icons from many interrelated perspectives: artistic, theological, historical, ecclesial, scriptural, and so on. Therefore, the two initial

chapters in part 1 are essential reading for those approaching the visual gospel of Orthodox icons for the first time.

This book is more than an academic exploration of icons, however. Part 2 marks the beginning of an immersive experience—an unfolding narrative journey through eighteen pivotal events in the life of Christ as depicted in the New Testament Gospels. Each event is brought to life in form and color through Orthodox icons, accompanied by descriptions and narrations of the messages they convey.

The order of icons presented in part 2 mirrors the order of the written Gospels, beginning first with the announcement to Mary about her role in the coming of God's Son and concluding with the Descent of the Holy Spirit at **Pentecost**, fifty days after Christ's **Resurrection**. The ten chapters of part 2 cover a total of eighteen encounters with Jesus Christ and, in a way, communicate the essence of the New Testament Gospels in both visual and textual forms.

While all Orthodox icons share certain common visual attributes (such as the **halo** surrounding the head of Jesus Christ always being inscribed with the Cross), these recurring characteristics will not be repeatedly explained at each occurrence. Therefore, it is advisable for readers to follow the chapters of part 2 in order. Nevertheless, in many cases, when a fundamental iconographic feature reappears, references are made to previous and subsequent chapters to indicate where detailed discussions occur.

To enhance understanding, a glossary is also provided. New terms and expressions directly related to Orthodox icons are displayed in bold type at their first occurrence, indicating that they are explained in greater detail in the glossary. A brief selected bibliography also includes a list of texts that are recommended for the reader seeking more information about the **holy images** of the Orthodox Church.

PART 1

A Basic Introduction to Icons

1

A Visual Biblical Worldview

The Visible Reveals the Invisible

The Evangelist John opens his Gospel by proclaiming a profound truth: The divine Word of God took on human form and became one of us. He came in the flesh, and was heard, seen, and touched (John 1:1–5; 1 John 1:1). John adds an important and pivotal truth: "No one has seen God at any time. The only begotten Son, who is in the bosom of the Father, He has declared Him" (John 1:18). However, the English translation obscures something very important! The Greek word translated as "declared" in this version is literally "exegesis" as a verb: *exēgēsato*.[1] Exegesis describes the process of careful analysis that leads to a deeper understanding, often applied to Scripture. But in this verse, John is telling his readers that Jesus Himself *is* the actual exegesis of the Father. Jesus reveals the invisible God that no one has ever seen. The visible Word of God, Who declared "I and My Father are one" (John 10:30) and "who has seen me has seen the Father" (John 14:9), reveals the nature, character, and attributes of the invisible Father in Himself.

Saint Paul also affirmed that Jesus is "the image of the invisible God" (Col. 1:15). Also obscured from the English reader is that the

1. "Θεὸν οὐδεὶς ἑώρακεν πώποτε· ὁ μονογενὴς υἱὸς ὁ ὢν εἰς τὸν κόλπον τοῦ πατρός, ἐκεῖνος ἐξηγήσατο" (John 1:18).

Greek word Paul uses for "image" in that passage is "icon" (Greek: *eikōn*/εἰκών). In the Bible, *eikōn* refers to a "true image." Jesus is the Icon, or the true image of the invisible God. Stated another way, we could say that the visible and material presence of Jesus reveals the invisible and **immaterial** presence of God. This is **paradoxical** to natural understanding, but it is nonetheless the foundation and essence of the Christian gospel.

The Orthodox icon and the text of the written Gospels share this as central emphasis: God Himself took human form. The icon, whether painted on a single wood panel with egg tempera paint or as a mural on church walls, visually presents the Gospel in a canonically defined manner. Saint Basil the Great, a respected bishop and teacher from the fourth century, eloquently expressed this connection: "What the word transmits through the ear, that painting silently shows through the image, and by these two means, mutually accompanying one another, we receive knowledge of one and the same thing."[2]

A Unique Form of "Show and Tell"

The men and women who create Orthodox icons are called iconographers. They show people and tell Bible stories through their icons in a way quite unlike what is done through any other visual medium. To the unfamiliar eye, icons may seem strange and flat—like a primitive art form awaiting the discovery of three-dimensional techniques. Yet it is not actually the case that ancient iconographers did not understand the techniques used in three-dimensional art. In reality, the perceived "flatness" and "strangeness" of Orthodox icons are very intentional and not signs of immaturity or crudeness in the art form. As we shall see in part 2, the absence of natural dimension is one of the ways by which iconographers strive to present "otherworldliness"— the aspect of being "not of the world" while still in the world (e.g.,

2. Basil the Great, "Discourse 19 on the 40 Martyrs," quoted in Vladimir Lossky and Leonid Ouspensky, *The Meaning of Icons* (Crestwood, NY: St. Vladimir's Seminary Press, 1982), 30.

Rom. 12:2; John 17:16; 1 John 2:15). Even if for no other reason, the way in which Orthodox icons show people and tell biblical stories is worth investigating because it is so completely different from the approach in more familiar visual media.

A photograph, for example, captures a moment in time; an icon also captures a moment in time but extends that specific historical moment beyond time into God's eternity. Classical portraiture tries to add "something more" to a painted image to show the character or demeanor of a person. With the "something more" in **iconography** it is possible to tell whether a person portrayed is a martyr, a prophet, a messenger of God—or even an unrepentant sinner—by certain added attributes.[3]

An impressionistic or abstract painter purposefully distorts elements of the natural world to capture a unique perspective or atmosphere of a scene. Similarly, icons achieve this by manipulating the angles and perspective of structures and exaggerating natural features, such as trees or mountains. These alterations are intended to emphasize the transformative impact of the presence of the **incarnate** God within the scene. The natural order itself has become transfigured by Jesus Christ (see Matt. 17:1–8; Mark 9:2–8; Luke 9:28–36).

A storyboard or graphic novel employs multiple frames to illustrate a sequence of events and adds conversation bubbles to show what the characters are thinking or saying. The icon, however, has no need for conversation bubbles since the narrative details are in the Bible. A sequence of biblical events is rendered by simply compressing all the actions on the same visual plane. Sometimes Christ is even shown in multiple places on one icon to illustrate sequential actions.[4]

Orthodox icons offer a unique combination of all these contemporary methods of visual communication. If we were to blend all the

3. Specific attributes will be identified through the process of describing icons and their meanings in part 2.

4. In part 2, icons that render Jesus in multiple places on one panel are the Nativity Icons in chap. 6 and Christ Calming the Storm at Sea, The Feeding of the Five Thousand, and The Transfiguration in chap. 9.

methods together, we might come closer to capturing how icons enable us to "see" the gospel. They indeed provide glimpses into specific moments of time, capturing the character, demeanor, or mission of individuals, as well as a sequence of events. However, the icon must go beyond mere representation. Similar to how the written words of the Bible convey timeless truths, icons must convey visually that the ultimate meaning of biblical events transcend the physical realm into a spiritual and universal dimension.

For this reason, icons are often referred to as "windows into heaven" because their meaning reaches beyond the limits of the natural world into the divine realm. For example, Mary said yes to God's plan to bear His Son at a particular moment in history: "Let it be to me according to your word" (Luke 1:38). That moment, however, immediately became a cosmic event, in which the Creator of the universe entered created time and forever transformed it. The icon is able to convey something of that eternal reality above and beyond the event's natural earthbound reality, without also neglecting the crucial fact that Christianity is a historical faith because God entered time and took on a material form within human history. As a result, the icon is also something of a **theophany**—a manifestation of God within historical moments.

The iconographer's task is far more complex than merely showing a person or telling a story. Iconographers must convey that people and history itself have become altered—illumined, transformed, and transfigured—by contact with the incarnate Lord. The iconographic tradition uses a specific visual language to achieve the seemingly paradoxical perspective of the subject as being in the world but "not of the world" (John 17:14–15).

Therefore, the icon is not bound by the laws of nature, but rather shows an altered version of natural forms to reflect what has become transfigured by God's indwelling of creation. The human form is also not portrayed according to nature, but features are exaggerated or minimized to convey spiritualized meaning. According to contemporary iconographer Solrunn Nes, "The drawing of the figure

is entirely schematic and stylized, and features such as an elongated ascetic body, large eyes, and a small nose and mouth show that the person portrayed belongs to another dimension."[5]

Reading and Writing Icons

Icons are not considered merely as "art" or even "religious art" in the Orthodox Christian world. Instead, they are seen as a form of visual interpretation or a **hermeneutic** through which the gospel message can be read. In fact, it is common for Orthodox Christians to refer to icons as being "written" even though they may have been painted. This distinction reflects the belief that icons hold significance beyond artistic qualities. Similarly, many believers do not approach the Bible simply as a piece of literature but consider Holy Scripture to be the preeminent written form of God's revelation to the created world. Both icons and the Bible are much more than works of human talent or creative inspiration from the minds of the painters or authors— they are vehicles for encountering God.

Iconographers must be faithful members of the Orthodox Church. Just as the authors of Holy Scripture possessed particular literary skills to communicate infinite truth in the finite language of humanity, iconographers must also possess the artistic skills to communicate the gospel visually. However, as with the Bible, neither the content nor the skill originates solely from human imagination or action. Rather, there is an essential **synergy** of the Holy Spirit's guidance on the divine side of things and the willingness of the individual to pay attention to the Holy Spirit on the human side of things. The human prayerfully offers both innate and divinely given skill, time, and energy to the "writing."

Preparation for painting by the iconographer includes prayer and fasting, very much like the preparation for participation in worship and the Holy Eucharist. This is because the icon itself is a form of

5. Solrunn Nes, *The Mystical Language of Icons* (Grand Rapids: Eerdmans, 2007), 20.

preaching about the Kingdom of God. Consider this excerpt from a typical prayer of an iconographer before beginning work:

> Enlighten and direct my soul, my heart and my spirit. Guide the hands of your unworthy servant so that I may worthily and perfectly portray Your Icon, that of Your Mother, and all the Saints, for the glory, joy and adornment of Thy Holy Church. Forgive my sins and the sins of those who will **venerate** these icons and who, kneeling devoutly before them, give homage to those they represent. Protect them from all evil and instruct them with good counsel.[6]

Saint Luke, the physician and Evangelist (who is also traditionally identified as having painted the first icon),[7] begins his Gospel account by making it clear to his readers that he has taken great care to "set in order" the written narrative about the things Jesus Christ has fulfilled (Luke 1:1). Similarly, the iconographer does not generate original content but also strives to "set in order" a visual account of the gospel, taking great care to accurately represent what has been conveyed to the Church by the Holy Spirit. The iconographer's personal aesthetic becomes submissive to the theological vision of the Church. For this reason, Orthodox icons are almost never signed.

How Icons Function

Icons serve a diverse range of functions in the Orthodox worldview, spanning from personal devotion as a focal point for prayer and

6. Jim Forest, *Praying with Icons* (Maryknoll, NY: Orbis Books, 2008), xviii, bold added.

7. The first icon is traditionally said to have been painted by Luke of the Virgin Mary and titled "Our Guide" (Greek *odēgētria*/οδηγήτρια). Some scholars have suggested that the connection of icons to the Evangelist Luke was a later tradition that arose in support of the antiquity of icons during the period of iconoclasm. However, as church historian Jaroslav Pelikan notes, the evidence predates Iconoclasm: "At least since the sixth century, it was the evangelist Luke who had also been identified as the originator of icon painting, having executed the earliest icons of the Virgin Mary" (Jaroslav Pelikan, *Imago Dei: The Byzantine Apologia for Icons* [Princeton: Princeton University Press, 2011], 88). See also Bissera V. Pentcheva, *Icons and Power: The Mother of God in Byzantium* (University Park: Pennsylvania State University Press, 2010), 125.

contemplation[8] to a prominent and essential role in corporate liturgical worship. Icons possess the power to educate, but their significance extends beyond mere storytelling. Icons also serve an important apologetic function by articulating and affirming correct dogma as a tangible representation of the Christian Faith.

The Didactic or Teaching Function

Because icons communicate the gospel in form and color, they have become invaluable sources of instruction for people of all ages, regardless of their ability to read. The eighth-century Byzantine theologian Saint John of Damascus referred to icons as "books of the illiterate . . . teaching without the use of words those who gaze upon them, and sanctifying the sense of sight."[9]

Just as the words of Holy Scripture are fruitful for teaching, so too are the visual representations in Holy Icons. Both are divinely inspired, as they are "given by inspiration of God . . . profitable for doctrine, for reproof, for correction, for instruction in righteousness" (2 Tim. 3:16). For this reason, there can never exist a dogmatic contradiction between teachings conveyed by Holy Scripture and those revealed through holy image, since both stem from the same source of revelation—the one Holy Spirit.[10]

The Apologetic or Dogmatic Function

Holy images have also been helpful across the centuries in countering theological error. An example of the apologetic function of icons comes from a seventh-century monk, Anastasios of Sinai. Anastasios

8. Although the devotional aspect of icons is extremely important to Orthodox Christians, it falls beyond the scope of this present book. A highly recommended introduction is Forest, *Praying with Icons*.

9. John of Damascus, "Ancient Documentation and Testimony of the Holy Fathers Concerning Images," in *On the Divine Images*, trans. David Anderson (Crestwood, NY: St. Vladimir's Seminary Press, 1980), 39.

10. Eve Tibbs, *A Basic Guide to Eastern Orthodox Theology: Introducing Beliefs and Practices* (Grand Rapids: Baker Academic, 2021), 46–50.

became frustrated with those who twisted the words of Scripture to serve their own agendas (today we call this "proof texting") to teach incorrectly that Jesus had only one nature. Anastasios believed that icons afforded a better way to express the proper understanding of the Incarnation, since the image could not be manipulated in the same way as the text.

Anastasios referenced only one icon: the Crucifixion. It proved to be an effective tool against the Monophysites (who said Jesus had one nature) to express the correct teaching about Christ's two natures. As we will see in greater detail in chapter 11, the Icon of the Crucifixion conveys in form and color the consensus of the **undivided Church** about the inseparability of the divine and human natures of Jesus Christ.

In the present day, I might also suggest that the Orthodox Icon of the Resurrection serves a dogmatic function by presenting a fundamentally different way of thinking about Christ's Resurrection than the prevailing Western view. The Icon of the Resurrection presents a communal Resurrection, for example, consistent with the Evangelist Matthew's testimony that many dead were raised and were seen coming out of their graves after Christ's Resurrection (Matt. 27:52–53). The Christian West, however, celebrates more the rising of the solitary Jesus.[11] This point will be discussed in detail in chapter 11 under the heading "The Resurrection Icon."

The Liturgical Function

The primary function of icons in the Orthodox Church is liturgical. Icons are displayed everywhere in Orthodox churches, large

11. John Dominic Crossan, a retired New Testament scholar and former Roman Catholic priest, together with his photographer wife, traveled the world photographing ancient Orthodox icons of the Resurrection of Christ. As evidenced by the title of the resulting book, Crossan concluded that the Orthodox icons of the Resurrection best reflect the biblical testimony and the ancient Resurrection tradition. See John Dominic Crossan and Sarah Sexton Crossan, *Resurrecting Easter: How the West Lost and the East Kept the Original Easter Vision* (New York: HarperCollins, 2018).

and small—on walls, on stands, on vestments, on banners, on the **iconostasis** (**icon screen**) before the **altar**, in the apse behind the altar, in the dome, and elsewhere. Icons are carried in procession on **feast days** and are venerated by the faithful as they prepare to enter into worship. Paul Evdokimov, a twentieth-century Russian-born professor of theology, writes that "in a nutshell, the icon is sacramental for the Christian East; more precisely, it is the vehicle of a personal presence."[12]

The icons of Jesus Christ, Apostles, prophets, martyrs, and other Saints that adorn the walls of Orthodox churches make visible and present the "great cloud of witnesses" (Heb. 12:1), who are continually worshiping God at His eternal throne. John of Damascus captured this same emphasis when he conveyed that in times of mental torment, he sought solace in the Church: "Suppose I have few books, or little leisure for reading, but walk into the spiritual hospital—that is to say, a church—with my soul choking from the prickles of thorny thoughts, and thus afflicted I see before me the brilliance of the icon. I am refreshed as if in a verdant meadow, and thus my soul is led to glorify God."[13]

The Icon, the Opera, and Presence

Each of the icons presented in part 2 of this book represents an event involving Jesus from one or more of the four Gospels. While Orthodox icons may appear unfamiliar as compared to Western religious art, it is highly probable that even a casual observer would be able to recognize Jesus Christ and perhaps even identify the specific New Testament event depicted. Yet important theological details that provide crucial context or background information might be overlooked or misunderstood. For example, what does the **red drape** represent

12. Paul Evdokimov, *The Art of the Icon: A Theology of Beauty*, trans. Fr. Steven Bigham (Redondo Beach, CA: Oakwood, 1990), 178.

13. John of Damascus, *On the Divine Images*, trans. David Anderson (Crestwood, NY: St. Vladimir's Seminary Press, 1980), 39.

in the Icon of the Annunciation to Mary?[14] Why is there an **ax** in the Icon of the Baptism of Christ?[15]

In a similar vein, attending an opera performed in an unfamiliar language (often still performed in their original French, Italian, or German) allows one to grasp the overall themes and emotions conveyed by the main characters through their actions and demeanors. However, without understanding the language, significant details about the setting, the relationships between characters, and the intricacies of their conversations are likely to be missed.

In the bygone era of candlelit theaters, opera enthusiasts often carried booklets containing the libretto (text) in two languages, enabling them to read along as the performance unfolded on stage. Nowadays, contemporary opera productions incorporate supertitles, which display real-time translations above the stage on video screens. One might question why individuals would bother attending an opera when they have the complete libretto at their disposal. However, the power of opera lies in its ability to convey meaning and beauty in ways that the text alone cannot accomplish. The performers bring the story to life, immersing the audience in their world. The visual and textual elements complement one another, mutually enhancing the experience. One is not diminished but is rather enriched by the other. In a way, both are necessary.

Something like a libretto or supertitle could be very helpful for translating the unfamiliar language of Orthodox icons. As it happens, we have such a thing! The Bible is like a libretto for icons. The Bible serves as a comprehensive guide, providing background information, conversations, settings, details, character development, and spiritual insights related to each encounter with Jesus Christ depicted in an Orthodox icon. The relationship between the text of Holy Scripture and the holy image can be understood analogously to the libretto for an opera. Both the icon and the opera convey something more to the viewer than a literal transcription of the text. The icon brings the

14. See chap. 5, "The Annunciation to Mary."
15. See chap. 8, "The Baptism of Christ."

words of Holy Scripture to life in a unique visible form—invoking deeper meaning and beauty the text alone cannot express. Moreover, the icon has the ability to invite the viewer into the **transcendent** presence of Christ that radiates from within the sacred image.

True Image and False Image

The Challenge of Bible Translations

Bible translations are certainly helpful in making the New Testament accessible to individuals who may not read or understand the original Greek.[16] However, translations may occasionally cloud the original meaning intended by the author. Translators make word choice decisions based on many factors, including the translators' own ideologies, the intended purpose, and intended audience. Should the translation be as literal as possible or as meaningful as possible? Since more people today will hear the Bible read aloud in church than will read it for themselves, how it communicates when read aloud can also be a factor in translation word choice.[17]

The Greek language is known for its rich and descriptive nature, with many nuanced words and expressions. Often when translating from Greek to another language such as English, the linguistic depth and subtleties of the original language can be lost. This phenomenon can be observed, for instance, in the translation of three distinct Greek words for different types of affection (*agapē, filia, storgē*),[18] all of which are commonly rendered as "love" in most English translations. Because of the linguistic richness and specificity of the original

16. According to Wycliffe Bible Translators, as of September 2023, at least one book of the Bible is available in 3,658 languages. The entire New Testament is available in 1,658 languages and the full Bible in 736 languages. See https://www.wycliffe.net/resources/statistics/.

17. Paul D. Wegner, *The Journey from Texts to Translations: The Origin and Development of the Bible* (Grand Rapids: Baker Academic, 2004), 393.

18. Examples of these three different Greek words in the New Testament are found in these passages: 1 Cor. 13:1; Rom. 12:10; and John 21:15. These three words are all translated in English as "love."

Greek, rendering the multiple Greek terms as a single English word undermines precision in understanding.

Ambiguity: Hot Is Cold, True Is False

Imagine the confusion that would occur if opposite words were translated with the same English word. For example, what if the Greek words for "hot" and "cold" were both translated simply as "temperature" in English? This kind of ambiguity has happened with the word "image" in most English translations of the Bible. The words that mean "false image" and "true image" in both Hebrew and Greek are rendered simply as "image" in most English translations. As might be expected, this has often caused a misunderstanding about God's view of images.

Think of the Second Commandment, in which an "image" is presented as something negative to be avoided at all costs: "Thou shalt not make unto thee any graven image" (Exod. 20:4 KJV). What kind of "image" is prohibited? The word translated as "image" in the Hebrew text is *pesel*, which refers to an idol or a false image. Similarly, in the **Septuagint** (the Greek translation of the Old Testament from the third century BC),[19] the word translated as "image" is *eidōlon* (εἴδωλον), which obviously refers to an idol. When these Hebrew and Greek words that mean "idol" are simply rendered into English as "image," this translation choice clearly undermines precision in understanding.

In the Second Commandment, the Lord is telling Moses that the Israelites should never make carved idols and bow down to them or serve them.[20] It is unfortunate that the translation of the Hebrew *pesel* and the Greek *eidōlon* as "image" rather than "idol" has conveyed

19. The Septuagint Greek Old Testament (LXX) is the version most often quoted by Christ and the New Testament authors. See Timothy Law, *When God Spoke Greek: The Septuagint and the Making of the Christian Bible* (Oxford: Oxford University Press, 2013).

20. "Graven" simply means carved, which is explicit in the NKJV: "You shall not make for yourself a carved image" (Exod. 20:4).

a false impression to English readers that *all* visual expressions are forbidden by God. Further in the same book, the Lord gives Moses explicit instructions on how the Ark of the Covenant should be elaborately decorated with golden images of cherubim, branches, almond blossoms, and so on (see Exod. 25). Contemporary Orthodox scholar Anton Vrame affirms that the earliest supporters of icons understood "that the Hebrew Scriptures argued against paganism yet advocated imagery in worship."[21]

True Images

Apart from false images, the Bible includes a specific word to describe true images of God. In Greek, the word used to describe what is understood as a true image is *eikōn* (εἰκών) (or "icon" in English).[22] However, *eikōn* is often translated only as "image" without any added qualification as being a "true" image. This translation choice has also contributed to misunderstanding. *Eikona* (a form of the word *eikōn*) is found at the very beginning of the Bible in Genesis 1:26: "And God said, 'Let us make man in our image [*eikona*/icon].'"[23] In essence, the triune God stated the intention to create humankind as an icon, or true image, that reflects the way God exists and embodies God's nature.

Whatever else is meant by the Genesis passage, it emphasizes that humans are not just any image, but a true image—an **icon of God**. In a sense, then, God is the original creator of icons! John of Damascus writes that "God Himself first made an image, and presented images to our sight, for 'God created (the first) man in His own image' (Gen.

21. Anton C. Vrame. *The Educating Icon: Teaching Wisdom and Holiness in the Orthodox Way* (Brookline, MA: Holy Cross Orthodox Press, 1999), 35. At the time of this writing, Rev. Dr. Anton Vrame is the newly elected Bishop Antonios of Synades.

22. The Hebrew word to describe a true image is *tselem* (e.g., Gen. 1:26–27).

23. *Eikona* is the word used in Genesis (e.g., 1:26, 27; 5:1, 3) in the LXX. It is used in a positive sense everywhere, except in Revelation 13:14, where it appears as the image of the beast. In that usage, the word represents a parody of truth—it is the "true image" in a warped sense, of everything opposed to God.

1:27)."[24] Nes refers to God as "the first artist,"[25] creating us as an icon according to the divine prototype.

In the New Testament, the same Greek root word for "true image" or "icon" (εἰκών) is used to describe how those who saw Jesus also encountered His Father: "He is the image [*eikōn*] of the invisible God, the firstborn over all creation" (Col. 1:15). Genesis, Colossians, and a host of other scriptural references announce that God's true image has been revealed by Jesus—the incarnate Son of God—through the physical stuff of the created world. "God the Father still could not be depicted, but his image—the Son—could."[26] This point is important and relates directly to the holy images of Orthodox iconography, in that created matter (such as wood, paint, and glass) could now serve as an acceptable means to convey God's eternal purpose within the material world.

24. John of Damascus, "Second Apology against Those Who Attack the Divine Images," in *On the Divine Images*, trans. David Anderson (Crestwood, NY: St. Vladimir's Seminary Press, 1980), 65.

25. Solrunn Nes, *The Uncreated Light: An Iconographical Study of the Transfiguration in the Eastern Church* (Grand Rapids: Eerdmans, 2007), 52.

26. Vrame, *Educating Icon*, 34.

2

The Iconoclast Controversy

A "Perfect Storm" of Misunderstanding

From the early centuries of Christianity, visual depictions of Jesus Christ and biblical events in the life of Christ have been integral in personal devotion, instruction, and worship. The iconographic tradition was widely accepted within the early church until the early eighth century, when "a campaign of words was launched against icons,"[1] sparking a major controversy that came to define the era. The two main sides were identified by the terms **iconodules** or **iconophiles** (literally, "icon servants" or "icon lovers"), who supported the creation and use of icons in prayer and worship, and **iconoclasts** (literally, "icon smashers"), who opposed icons and destroyed them. Although the variety of iconoclast views are extant only through their opponents' writings, influential church historian Jaroslav Pelikan notes that there is every reason to consider these as trustworthy representations of both sides of the theological debate.[2] Ultimately, the

1. Mike Humphreys, ed., *A Companion to Byzantine Iconoclasm* (Leiden: Brill, 2021), 2–5. Humphreys is an Oxford professor of Byzantine History.
2. Jaroslav Pelikan, *Imago Dei: The Byzantine Apologia for Icons* (Princeton: Princeton University Press, 2011). Jaroslav Pelikan (1923–2006) was an ordained

iconodule position prevailed in the Church—but not without a great deal of turmoil, persecution, and even bloodshed.[3]

Various religious and sociopolitical factors in the **Byzantine Empire** at that time converged as something like a perfect storm. It was Emperor Leo III, known as the Isaurian, who stood in the eye of the storm of iconoclasm. Influenced by the prevailing ideology of Islam that prohibited the depiction of living beings, Leo played a significant role in challenging the use of icons, especially through his harsh actions against Christians who supported them.[4] In 730, Leo issued an edict denouncing icons as idols and ordered the destruction of thousands of icons, beginning with the Icon of Jesus Christ on the Chalke Gate leading into his palace. Iconodules who openly objected to his extreme measures were subjected to brutal arrests, torture, and exile. After Leo's death, his son Constantine V continued the persecution of iconodules with great fervor, even to the point of executing sixteen iconodule martyrs in 766.[5]

Theological Issues of the Controversy

The uncertainty and turmoil brought about by radical iconoclast emperors was further fueled by the underlying theological challenges to icons. These included the misinterpretation of the Second Commandment[6] and remnants of Platonism and **Gnosticism** that continued to

Lutheran pastor and Sterling Professor of History at Yale University and was the author of more than thirty books. He was received into the Orthodox Church in 1998.

3. Anton C. Vrame offers a robust and accessible summary of the controversy from both a historical and a theological perspective in *The Educating Icon: Teaching Wisdom and Holiness in the Orthodox Way* (Brookline, MA: Holy Cross Orthodox Press, 1999), 21–62. A succinct summary of iconoclasm is also found in Solrunn Nes, *The Mystical Language of Icons* (Grand Rapids: Eerdmans, 2007), 14–15.

4. Leo was also said to have blamed the presence of icons for defeats his empire suffered against Muslim forces. See Michael Frassetto, *Christians and Muslims in the Middle Ages: From Muhammad to Dante* (London: Rowman & Littlefield, 2020), 47.

5. John Anthony McGuckin, ed., *The Concise Encyclopedia of Orthodox Christianity* (Chichester: Wiley-Blackwell, 2014), 134.

6. See the earlier discussion of the Second Commandment in chap. 1, under the heading "True Image and False Image."

challenge the Christian belief in the Incarnation of the Son of God.[7] While on the surface the controversy may seem to have been related to a proper understanding of visual imagery, what was really at stake was the Christian attitude toward matter—and particularly the materiality of Christ's Incarnate personhood. The iconodules claimed that the iconoclast arguments against the icons stemmed from incorrect views of Christ's Incarnation. What's more, the iconodules argued that a proper **Christological** outlook would not only support the creation of icons and their use in personal devotion and corporate worship but would prove that they are essential to the Christian Faith.

Does Matter Matter?

Saint John of Damascus was a prominent defender of icons during that period and agreed with the iconoclasts that it would indeed be impossible to depict a formless and immaterial God. Yet God was no longer formless and immaterial, having become visible in Jesus Christ: "In former times God, who is without form or body, could never be depicted. But now when God is seen in the flesh conversing with men, I make an image of the God whom I see."[8]

One argument put forth by the iconoclasts was that creating an image depicting Christ's human nature could lead to idolatry, as the worship of a created object. An opposite iconoclast argument was that an image portraying Christ's divine nature would be blasphemy since God is immaterial and "**uncircumscribable.**" Both arguments failed for the same reason: Christ's two natures can never be separated from one another. Jesus is one person in two natures, fully God and fully human, and the icon reflects both natures together.[9]

7. Frassetto, *Christians and Muslims in the Middle Ages*, 47.

8. John of Damascus, "First Apology against Those Who Attack the Divine Images," in *On the Divine Images*, trans. David Anderson (Crestwood, NY: St. Vladimir's Seminary Press, 1980), 23.

9. It was three centuries earlier when the Fathers of the Fourth Ecumenical Council met in Chalcedon to discern, through the guidance of the Holy Spirit, the proper way to consider Jesus Christ's two natures. The consensus was that Christ's human "material" nature and His divine "immaterial" nature are joined in a "hypostatic

Moreover, the icon can in no way be idolatrous, nor is the icon related in any way to the worship of physical material. John of Damascus argues: "I do not worship matter, but the Creator of matter, who for my sake became material and deigned to dwell in matter, who through matter effected my salvation."[10] While an icon may be reverenced for what and whom it presents, all expressions of worship are always directed only to the Creator of all matter, who took on material form for the sake of His creation. Because of this, the Damascene advises, "Go ahead and image him in icons and present him for viewing, *as one who wanted to be viewed*."[11] Similarly, Gerhart Ladner, a medieval scholar and Jewish convert to Christianity, wrote, "As perfect man, Christ not only can but *must* be represented and worshiped in image: let this be denied, and Christ's *oikonomia*, the **economy** of salvation, is virtually destroyed."[12]

Does Time Matter?

When "the Word became flesh" (John 1:14), He enabled created matter to participate in divinity. When the Word entered created time (Mark 1:14), He enabled history to participate in eternity. Therefore, time matters, just as matter matters! This means that proper understanding of the historicity of Christ's life is just as essential to understanding icons as a proper Christian understanding of matter.

When Saint John describes Jesus as sitting at Jacob's well, in a specific city of Samaria, and at the sixth hour (John 4:5–6), we learn

union" and cannot be divided or separated from one another. Further, His two natures were not changed in the Incarnation, meaning that Jesus Christ as one person is fully human and fully divine. See Henry Bettenson, ed., *Documents of the Christian Church*, 4th ed. (New York: Oxford University Press, 2011), 54.

10. John of Damascus, "First Apology," 10.

11. John of Damascus, "Orations on the Holy Icons I.8," quoted in Pelikan, *Imago Dei*, 83–84 (italics mine). Andrew Louth translates this phrase as follows: "then depict him on a board and set up to view the One who has been accepted to be seen." St. John of Damascus, *Three Treatises on the Divine Images*, Popular Patristics Series, trans. Andrew Louth (Crestwood, NY: St. Vladimir's Seminary Press, 2003), 24.

12. Gerhart B. Ladner, "Origin and Significance of the Byzantine Iconoclastic Controversy," in *Mediaeval Studies* 2, no. 1 (1940): 145 (italics and bold added).

that Jesus was actually there in that place at that time. When Saint Mark describes how Jesus slept through a storm at sea "in the stern, asleep on a pillow," we are told that He was really in a boat on the sea, on that pillow in the stern, at a specific time in history (Mark 4:35–41). According to Pelikan, "So it was with all the scenes in the Gospels: they had actually taken place at particular places and times, and therefore they could (and should) be iconized."[13]

The Seventh Ecumenical Council

The Seventh (and final) **Ecumenical Council** of the undivided Church was called by the iconodule Empress Irene (750–803) in Nicaea in 787.[14] The 367 bishops who traveled from the four corners of the ancient world to attend this council weighed all the arguments in consideration of a proper understanding of Christ's Incarnation. The Fathers of this council affirmed the Christology of the earlier fifth-century council at Chalcedon that Christ's human "material" nature and His divine "immaterial" nature are in a union that cannot be divided or separated from one another (a "**hypostatic unity**").[15]

This meant that God's nature has indeed been revealed in Jesus Christ, "the image of the invisible God" (Col. 1:15). Paul Evdokimov interprets Saint Paul's meaning in this way: "The visible humanity of Christ is the icon of his invisible divinity."[16] Therefore, matter matters! Matter has revealed God in the flesh! The eternal God could

13. Pelikan, *Imago Dei*, 83.

14. This is a much-shortened summary of the **Iconoclast Controversy**. There were actually two councils called, 130 years apart. The first council was called by Byzantine Empress Irene and restored the icons to their proper place of veneration. Iconoclasm arose again in the early ninth century, which necessitated another council called by Empress Theodora (815–ca. 867), after which icons were restored permanently in the Church.

15. See Eve Tibbs, *A Basic Guide to Eastern Orthodox Theology: Introducing Beliefs and Practices* (Grand Rapids: Baker Academic, 2021), 94.

16. Paul Evdokimov, *The Art of the Icon: A Theology of Beauty*, trans. Fr. Steven Bigham (Redondo Beach, CA: Oakwood, 1990), 183.

now be seen and touched and heard—and painted—because of the Incarnation of the Son of God (1 John 1:7).

Further, the members of the Seventh Ecumenical Council declared that icons provide "confirmation that the becoming man of the Word of God was real and not just imaginary" and thus they are "quite in harmony with the history of the spread of the gospel."[17] Having established the dogmatic position that the creation of icons was appropriate because of Christ's Incarnation, the council offered further instruction on how icons should be used in worship and displayed in the Church:

> We recognize that this tradition comes from the Holy Spirit who dwells in her [the Church]—we decree with full precision and care that, the figure of the honoured and life-giving cross, the revered and holy images, whether painted or made of mosaic or other suitable material, are to be exposed [visible] in the holy churches of God, on sacred instruments and vestments, on walls and panels, in houses and by public ways.[18]

The Fathers of the Seventh Council also determined that the holy images may receive "respectful veneration"[19] but definitely not worship (Greek: *latreia*), which is paid only to God. They clarified that any honor paid to a holy image, such as with offerings of **incense** or candles, goes beyond the actual image to the prototype: "He who venerates the image, venerates the person represented in that image."[20] In other words, the icon itself is nothing but a board with paint—but it offers something like a window to the holy person or event portrayed.

Finally, the council declared that the holy images were to be given the same honor as the four written Gospels because they proclaim

17. Norman P. Tanner, *Decrees of the Ecumenical Councils*, vol. 1, *Nicaea to Lateran V* (Washington, DC: Georgetown University Press, 1990), 135.

18. Tanner, *Decrees of the Ecumenical Councils*, 135, 136.

19. The actual phrase is τιμητική προσκύνησις (*timētikē proskynēsis*), which refers to reverence as a sign of honor.

20. Tanner, *Decrees of the Ecumenical Councils*, 135.

the same truth: "For, things that mutually illustrate one another undoubtedly possess one another's message."[21] It was not only that the image and text contained a similar message but that they both also generate the same outcome in the believer, which is that of offering proper doxology (the Greek meaning of the word "Orthodox") to God: "For, when they hear the gospel with the ears, they exclaim 'glory to Thee, O Lord'; and when they see it with the eyes, they send forth exactly the same doxology, for we are reminded of his life among men. That which the narrative declares in writing is the same as that which the icon does [in colors]."[22]

All of this leads us to the purpose of this book. Because God is the "first artist," creating humanity as an icon of God (Gen. 1:27); and because God became visible in Jesus, the visible Icon of the invisible Father (Col. 1:15); and because the icons convey the same message as the four Gospel writings; and because both the written Gospels and the icons lead to the same doxology, it is possible, appropriate, and even necessary to "see the gospel" in Orthodox iconography. With this brief summary of part 1, we move into part 2 to "see how we can see."

21. Tanner, *Decrees of the Ecumenical Councils*, 135.
22. Daniel J. Sahas, *Icon and Logos: Sources in Eighth-Century Iconoclasm* (Toronto: University of Toronto Press, 1986), 69. Sahas offers a full account of the Sixth Session of the Seventh Ecumenical Council in English.

Seeing the Gospel in Icons

3

Christ, the Giver of Light

The people who walked in darkness
Have seen a great light.

—Isaiah 9:2

Darkness and Light

Israel's Messiah was expected to bring "light to the nations" and to free those in darkness (Isa. 42:6–7). Saint John the Evangelist begins his New Testament Gospel with a profound connection to this expectation. God has indeed become flesh and has come as "the true light that gives light to everyone" (John 1:9, 14). As the incarnate Word of God, Jesus was not only heard and obeyed but, as Jaroslav Pelikan notes, "as Light, he was now there to be seen as well—and therefore to be visualized, also in the form of an icon."[1] So it is that the Icon of Christ the Giver of Light is a most appropriate way to begin our journey of exploration into the Orthodox icon as a "true image" of the "True Light" (John 1:9).

1. Jaroslav Pelikan, *Imago Dei: The Byzantine Apologia for Icons* (Princeton: Princeton University Press, 2011), 99.

Figure 3.1. Christ the Giver of Light

Light is the primary **motif** of all icons, but the icon by the hand of Fr. Tom Tsagalakis and the mosaic Icon of Christ both focus explicitly on the theme of Jesus Christ as the "Giver of Light." Christ's left hand is supporting the Book of the Gospels, with words from the

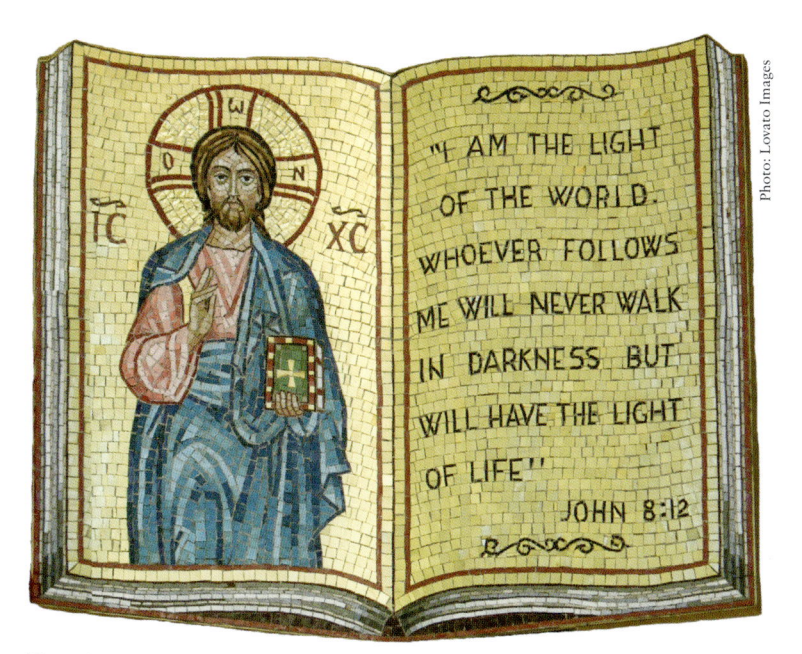

Photo: Lovato Images

Figure 3.2. Mosaic Icon of Christ from Saint Paul Greek Orthodox Church in Irvine, California

Gospel of Saint John: "I am the light of the world. He who follows Me will not walk in darkness, but have the light of life" (John 8:12).

The background of most icons of Jesus Christ (and most icons, generally) is gold, since gold best reflects light. In an icon, there is never a source of natural light, such as sunlight, since "light is their very subject, and we can never enlighten the sun."[2]

Progressive Enlightenment

Even the process of creating an icon focuses on the increasing of light as a metaphor for the Christian life in Christ. The Christian life itself is one of progressive enlightenment. We are to grow in **grace**

2. Paul Evdokimov, *The Art of the Icon: A Theology of Beauty*, trans. Fr. Steven Bigham (Redondo Beach, CA: Oakwood, 1990), 186.

Figure 3.3. Fourteenth-century Icon of Christ (**Pantocrator**, the Almighty) from the main dome of the Gračanica Monastery in Kosovo, Serbia

and knowledge (2 Pet. 3:18), walking in Christ's light (Eph. 5:8) and reflecting His glory as we are being transformed into the likeness of Christ (2 Cor. 3:18). The technique of painting icons is similarly called progressive enlightenment. The transfigured faces of Christ and the saints are first painted with a dark color. Then brighter colors are systematically added on top of each darker color, with the brightest colors at the topmost layer. This technique also parallels the progressive revealing of God's glory as light, as in Jesus's **Transfiguration** on Mount Tabor, when "His face shone like the sun, and His clothes became as white as the light" (Matt. 17:2).[3]

3. See also Matt. 17:1–9; Mark 9:2–10; Luke 9:28–36; and Evdokimov, *Art of the Icon*, 186.

Symbolic Elements in the Icon of Christ

Color often plays a symbolic role in icons, although color may also be used in a merely aesthetic way—for example, to emphasize a solemn or a joyful event. The color of the robe of Jesus Christ is usually

By the hand of Michael Kapeluck

Figure 3.4. Christ the Savior

Figure 3.5. Pantocrator (Christ the Almighty) from the eleventh-century Monastery of Hosios Loukas in Greece

significant. Red typically symbolizes earthly things, such as blood, fire, earth, and humanity. Blue is often used to emphasize divinity and the mystical life. In many icons, Christ's inner robe is red while the outer robe is blue, emphasizing both humanity and divinity.[4]

Another of the symbolic aspects relating to Christ's two natures are the two small strands of hair at His hairline. If they are present, as in the eleventh-century circular mosaic from the Hosios Loukas

4. Jim Forest points out that although the colors used in an icon will depend on the local tradition, the iconographer, and what is available, blue is typically associated with heaven and purity, while red, the color of blood, is associated with humanity and vitality. Jim Forest, *Praying with Icons* (Maryknoll, NY: Orbis Books, 2008), 29.

Photo: Denise Canellos

Figure 3.6. Icon of Jesus Christ, shared by Denise Canello

Monastery[5] in Greece, they represent Christ's two natures—fully human and fully divine. Here, Christ's face is peaceful and meek, reflecting humility. The nose is straight and elongated; the eyes are large

5. *Hosios* means "esteemed" or "blessed"—as the "Monastery of the esteemed Luke."

and dilated, looking at the viewer with attentive concern but without condemnation. "For God did not send His Son into the world to condemn the world, but that the world through Him might be saved" (John 3:17).

Notably, Christ's halo wraps fully around His head, and it will always be inscribed with a cross. Jesus ascended the Cross out of love for His creation (John 19:17); therefore, "Christianity is the Religion of the Cross."[6] Three letters are usually inscribed in the Cross, comprising the two Old Testament Greek words—ὁ ὤν (English: "I AM")—that were spoken to Moses from within the burning bush (Exod. 3:14).[7] The placement of these words in Jesus Christ's halo declares that He is the same eternal Logos of God—the Word Who spoke to Moses—now incarnate.

To the left and right of Christ's head are four additional letters. They hearken back to Israel's use of four letters, called the **tetragrammaton**, to refer to the name of God: YHWH (Hebrew: יהוה).[8] The four letters of YHWH not only serve as a pattern for the four letters of ICXC in the icon but also establish a theological connection. ICXC, formed from the first and last letters of Greek words for "Jesus Christ" (Ἰησοῦς Χριστός), highlights that Jesus Christ is the very embodiment of the Lord God Himself. These four letters also become the iconographic shorthand of His name. Jesus also forms those four letters with His right hand,[9] offering a blessing of grace in His name to the one contemplating "the glory due His name" (Ps. 96:8 [95:8 LXX]).[10]

6. Georges Florovsky, "On the Tree of the Cross," *Saint Vladimir's Seminary Quarterly* 1, nos. 3-4 (1953): 11.

7. In Hebrew, "I AM" is just rendered as one word: אֶהְיֶה.

8. See the robust and well-cited biblical analysis of Christological concepts in Veli-Matti Kärkkäinen, *Christology: A Global Introduction* (Grand Rapids: Baker Academic, 2016), 20n22.

9. One finger is straight for the I. Two fingers are crossed to make the χ. Two fingers are curved to make the two ending sigmas (ς).

10. The numbering of Psalms differs between the third-century BC Greek version of the Old Testament (identified as the Septuagint, or LXX) and the later tenth-century Masoretic Text (MT), which is the version presented in most English Bibles.

By the hand of Father Tom Tsagalakis

Figure 3.7. Christ the Giver of Light Enthroned

Inverse Perspective

As with all furnishings and structures of iconography, the majestic throne of Christ is also not rendered according to natural form. As

Figure 3.8a. Natural perspective with the vanishing point at the horizon line

By the hand of Father Tom Tsagalakis

Figure 3.8b. Footstool from the above icon (fig. 3.7), demonstrating an inverse perspective vanishing point

there is no source of light, there are also no shadows. The absence of three-dimensional form is intended to remove any emphasis on earthly materiality, placing it instead on the transfiguring presence that shines outward.

The Icon of Christ the Giver of Light Enthroned by the hand of Fr. Tom Tsagalakis illustrates another attribute (or fixed feature) common in iconography: **inverse perspective**. The inverse perspective is the opposite of what is called the **"vanishing point,"** used in natural art to convey distance and dimension. The simplest illustration is a path with fences, which are wider in the foreground and converge at a single point in the distant part of the image.

Structures in Orthodox icons are intentionally not drawn in a natural way to show dimensionality. Furthermore, if one were to draw an imaginary line from the outside angles of the throne and the sides of Christ's footstool in this icon, the vanishing point would be seen projecting forward from the image toward the viewer. This technique not only defies any hint of a realistic viewpoint but also extends the imaginary parameters of the inverse vanishing point to include the viewer. The icon's onlooker is thus invited to an encounter with the icon's subject.

4

Messengers of God

John the Forerunner

In the New Testament, the Greek word for "messenger" is *angelos*, which explains why heavenly messengers are called "angels" in English. The first icon in this chapter portrays Saint John the Baptist and Forerunner of Christ. Even though John is often shown in iconography with wings, he was definitely not an immaterial angel, but an ordinary human man. The curious attribute of showing John with wings is due to the explicit connection made by Jesus about John in reference to the prophecy of Malachi 3:1:

> Behold, I send My messenger before Your face,
> Who will prepare Your way before You. (Matt. 11:10; Mark
> 1:2; Luke 7:27)

Wings in iconography are the attributes that signify a messenger—one sent to accomplish the will of God—but they do not necessarily signify flight or translocation.

The Forerunner John was also prophesied by Isaiah as "one crying in the wilderness" (Isa. 40:3). We are told in the Gospels of Matthew

By the hand of Michael Kapeluck

Figure 4.1. John the Baptist and Forerunner

and Mark that "John himself was clothed in camel's hair, with a leather belt around his waist; and his food was locusts and wild honey" (Matt. 3:4; similarly, Mark 1:6). In keeping with these descriptions and as the one coming from the wilderness, John's clothing

always resembles camel hair in icons, usually in a green ocher tone. His hair is shown as long and disheveled, and he has a shaggy beard. His expression is sober and serious. John is single-minded in his ministry to accomplish the will of God.

In most icons John is also shown holding a Cross, which indicates that he was martyred by Herod Antipas for calling attention to Herod's adultery (Matt. 14:10–12; Mark 6:27–29). Since the Forerunner always directs attention to Jesus Christ and away from himself ("He must increase, but I must decrease," John 3:30), his right hand is shown making the sign for the name of Jesus Christ (ICXC).[1]

Solrunn Nes points out that the icon treats both time and space as relative, with John being depicted in three different temporal dimensions simultaneously. The icon records his earthly life, his martyrdom, and his glorified status as a saint in heaven.[2]

Archangel Michael, "Commander of the Lord's Army"

The primary duty of the angelic host—the heavenly army of angels—is to safeguard God's creation against the evil powers that seek to destroy it. Consequently, the archangels are often depicted in military attire, signifying their active involvement in spiritual warfare on God's behalf. Consider the fifteenth-century icon (see fig. 4.2) from Crete of the Archangel Michael, whom Joshua calls "Commander of the Lord's Army" (Josh. 5:13–15). Michael is depicted in the attire of a soldier with breastplate armor. The sword here serves as a staff—a **symbol** of Michael's authority in the created world—but also symbolically as a weapon.

The archangel is also depicted with wings, but as mentioned with regard to John the Baptist, the wings identify Michael as an *angelos*— a messenger of God. The curled ribbon shown to the left and right

1. See description in chap. 3.
2. Solrunn Nes, *The Mystical Language of Icons* (Grand Rapids: Eerdmans, 2007), 65.

By the hand of Andreas Ritzos

Figure 4.2. Fifteenth-century Icon of Holy Saint Michael the Archangel, from Crete

Figure 4.3. Fourteenth-century Icon of Archangel Michael, from the Byzantine Museum in Athens

of his head, as if floating on a breeze, is the attribute that identifies the messenger's swift attentiveness to divine command.

This fourteenth-century panel depicts the Archangel Michael adorned in the liturgical vestments typically worn by an Orthodox deacon. Here Michael carries not a sword but a staff to show his authority as a messenger sent by God.

In the archangel's hand is a globe with the initials of Jesus Christ (IX) inscribed at the top. This signifies that the archangel's authority over the created world has been given by the Lord. The large Greek letters Δ and K on the globe are shorthand for the Greek words *Dikaios* (Δίκαιος), meaning "Righteous," and *Kritēs* (Κρίτης), or "Judge." Altogether, the four initials abbreviate the phrase "Jesus Christ [the] Righteous Judge." It is an expression that recalls the words of the Lord: "My judgment is righteous" (John 5:30).

The inscription at the upper left and right is a combination of abbreviations and full words, read from left to right across the same row, identifying the archangel as "the Prince Michael, the Great Commander"[3] as a reference to Daniel 12:1: "Michael . . . the great prince who stands watch over the sons of your people."

3. The Greek version of Dan. 12:1: Ὁ Ἄρχων Μιχαήλ ὁ μέγας ταξιάρχης.

5

The Annunciation to Mary

The Union of Heaven and Earth

One of the earliest examples of Christian iconography is the portrayal of the **Annunciation** of the Archangel Gabriel to the Virgin Mary. An image of this same event exists in the Catacomb of Priscilla in Rome, dated to the early second century.

The coming of our Lord and Savior Jesus Christ is announced near the beginning of Saint Luke's Gospel after the miraculous conception of John the Baptist by his aged parents Zacharias and Elizabeth. Elizabeth is in her sixth month when Gabriel visits Mary in Nazareth (Luke 1:26–38).

Luke often presents specific details in his writing, and his description of this event is no exception. He conveys that Gabriel was sent to a city of Galilee called Nazareth to speak to Mary, a virgin who was **betrothed** (Greek: *emnēsteumenēn*) to a man named Joseph. The action in Luke's Gospel begins when the angel enters, "having come in" (Luke 1:28).[1]

The archangel is seen entering from the left, moving toward the right, which is the typical direction of narrative action in icons. One

1. See chap. 3, under the heading "Progressive Enlightenment."

Figure 5.1. Fifteenth-century Russian Icon of the Annunciation, from the iconostasis of the Kirillo-Belozersky Monastery

reason for this is that the icon is read similarly to the Greek text in the New Testament, from left to right.

There are no walls in the icon to suggest that Gabriel had entered an indoor space, as would have been present in naturalistic art. The

Figure 5.2. The Annunciation to Mary, shown as standing

absence of enclosing walls in iconography is also intentional since the icon has no dimension or physical boundaries.[2] There is no light source, and therefore, there are no shadows. The absence of both walls and light sources serves to convey that the event itself expands beyond its natural earthbound limits. Evdokimov writes that the icon is "never a window on nature," not even on a specific place, "but rather an opening onto the beyond."[3]

It is the red drape that sets the scriptural event within its actual indoor historical setting, with the color red representing the earthly setting of this event. The red drape affirms that this event took place at a specific moment in history, in a specific indoor space in Nazareth, between a specific angel, Gabriel, and a specific young woman, Mary, in the "sixth month" after Elizabeth conceived (Luke 1:26–27, 36). Yet the icon goes beyond the historical setting to encompass the cosmic significance of this event: the eternal God enters human history.

Gabriel and Mary

The icon shows two main figures: the Archangel Gabriel and the Virgin Mary. Both are shown in full face and looking forward toward the viewer, offering an encounter. In the language of iconography, forward and full faces also identify them as righteous figures. Unrepentant sinners will normally be shown either in profile or with only a small portion of their face showing.

The Archangel Gabriel's stance is joyful and dynamic, filled with movement. His stance is wide, as if he was just running or had just landed. The sense of just-completed flight is supported by the one raised wing, and the flowing movement of his gown. The rigid lines

2. While some icons may depict exterior walls or architectural elements, their inclusion serves the purpose of framing the scene within a specific context, such as the temple in Jerusalem.

3. Paul Evdokimov, *The Art of the Icon: A Theology of Beauty*, trans. Fr. Steven Bigham (Redondo Beach, CA: Oakwood, 1990), 95.

Figure 5.3. The Annunciation to Mary

and angles in the gown contrast with the almost liquid form of the flowing scarf. Gabriel holds a staff in his left hand, which conveys that he has been given authority as a messenger (Greek: *angelos*) of God.[4] Gabriel's right hand is raised toward Mary in a gesture of blessing.

4. See chap. 4, "Messengers of God."

Mary is typically shown as seated, which emphasizes her superiority over the messenger. However, in some versions, such as the icon by the hand of Michael Kapeluck (fig. 5.2), Mary is standing, listening attentively. Whether she is shown as standing or as sitting, Mary's gestures appear restrained and subdued. In contrast to the archangel's exuberance, Mary's entire posture is rendered with composure, which is emphasized by the subdued tones of her garment.

Here again, color plays an important symbolic role. The deep red of Mary's gown over a blue inner garment is the exact inverse of Christ's clothing as seen in chapter 3 and attests to her role in the Incarnation of the Son of God. The outer red of Mary's clothes affirms that she is a human woman, while the inner blue affirms that she will contain divinity within her womb for nine months. It is the wonder of all wonders: how can the "Creator of the ends of the earth" (Isa. 40:28) be contained at all, much less in a woman's womb? Yet Christianity affirms that out of God's great love, He indeed sent His only begotten Son to become one of us (John 3:16).

One of the more unique aspects of Orthodox iconography is the absence of anything emotional or exclusively natural. Mary is clearly human, but her coloring and her features are exaggerated to show the transfigured quality of one who shares in divine grace. The **nimbus**, or halo, surrounding her head also accentuates the otherworldliness of this event and Mary's holiness as the "highly favored one" (Luke 1:28) as proclaimed by the archangel. In the Orthodox iconographic tradition, the halo is always connected to the body rather than shown as a circular ring floating above the head, as is often seen in Renaissance art.[5]

Spindle and Yarn

The conception of Jesus, the Son of God, is a central dogma of the Christian Faith. This event is made possible only through Christ's

5. For example, as in Leonardo DaVinci's fifteenth-century *The Annunciation*: see https://www.leonardodavinci.net/the-annunciation.jsp.

Figure 5.4. Fourteenth-century Icon of the Annunciation, from Serbia

self-emptying, known as **kenosis,** which Saint Paul discusses in his letter to the Philippians (2:6–11). Orthodox scholar Fr. Maximos Constas raises an intriguing question regarding the visual representation of Christ's self-emptying: "How could an event invisible to the naked

eye be expressed through the medium of art?" This paradox is conveyed through the "seemingly mundane activity of spinning thread."[6]

It is the spindle of red yarn that Mary is holding in her left hand that has become a prominent attribute, or fixed feature, of every version of this icon. The spindle and yarn symbolize Christ's self-emptying, while the yarn's red color represents humanity. This signifies that Christ willingly condescends to take on the human condition, and Mary consents to bear God's eternal Son, metaphorically weaving His humanity within her womb.

As the color red often appears in icons to emphasize earthly realities, its inclusion as the yarn's color underscores the profound connection between our earthly existence and the self-emptying condescension of Christ. It signifies His willingness to embrace and take on the human condition, illustrating the profound depth of His sacrifice and love for humanity.

A Prophetic Call

The presence of the spindle and yarn in the icon also suggests that Mary was preoccupied with a specific task. The unexpected appearance of a heavenly messenger aligns with the customary pattern seen in the prophetic "call" recounted throughout the Old Testament. Time and time again, the prophets of the Old Testament express surprise when summoned by God to leave behind their ordinary and embark upon extraordinary missions in His Name.

Also apparent in the call of some Old Testament prophets, especially of Moses, Gideon, and Jeremiah, is something like a reluctance, and even an opposition, to the call. Moses, for example, expressed many objections directly to God: "Who am I that I should go . . . ?" (Exod. 3:11), and "I am slow of speech and slow of tongue" (4:10). To each challenge, God in some way affirms: "I will be with you" (3:12).

6. Fr. Maximos Constas, *The Art of Seeing* (Alhambra, CA: Sebastian, 2014), 108.

Figure 5.5. Early fourteenth-century Icon of the Annunciation to Mary, from the Church of Saint Clement in Ohrid, Macedonia

We see this same surprise and reluctance in Mary, both in the written word of Luke's Gospel and in its rendering in the icon. The archangel exclaims: "Rejoice, highly favored one, the Lord is with you;

blessed are you among women!" (Luke 1:28). Here the three English words "highly favored one" are a single Greek word, *kecharitōmenē* (κεχαριτωμένη), which has "grace" (Greek: *charis*) at its root. Mary is being greeted as one full of the grace of God and blessed among women. She is troubled, therefore, not only by the archangel's surprise visit but especially by this highly exalted appellation (1:29). In her surprise, she even drops the yarn she is spinning.

Gabriel calms her fears and immediately announces the good news (Greek: εὐαγγέλιον/*euangelion*): "You will conceive in your womb and bring forth a Son, and shall call His name Jesus. He will be great, and will be called the Son of the Highest; and the Lord God will give Him the throne of His father David. And He will reign over the house of Jacob forever, and of His kingdom there will be no end" (Luke 1:31–33). As with Moses, Gideon, and Jeremiah, not only is Mary perplexed that she has been chosen by God for this purpose, but she actively protests the idea. The icon shows her opposition to this plan by her outstretched right hand with her palm facing outward—a sign of nonacceptance: "How can this be, since I do not know a man?" (1:34). Clearly, what the archangel has proclaimed seems quite impossible to Mary. However, as the Lord told Moses, "Go, and I will be with your mouth and teach you what you shall say" (Exod. 4:12), so also are Mary's concerns allayed. The archangel assures her that God will take care of all the details: "The Holy Spirit will come upon you, and the power of the Highest will overshadow you," affirming that "with God nothing will be impossible" (Luke 1:35, 37). With great faith, Mary responds with words that have made her the worthy role model of every faithful Christian believer, male or female: "Behold the maidservant of the Lord! Let it be to me according to your word" (1:38).

A Cosmic Event in One Panel

There are other important elements present in the icon of this event that are not as obvious as the two main figures. As with all Orthodox

By the hand of Michael Kapeluck

Figure 5.6. The Annunciation to Mary, shown as seated

icons, this icon of the Annunciation does not convey only one moment in time—it is not a snapshot. This icon renders not only the entire encounter between the Archangel Gabriel and the Virgin Mary but also its outcome and result—and does so efficiently in only one panel. Parallel to Luke's written account of this event, the icon presents the divine messenger's entrance, his greeting, and the

good news that God has chosen Mary to bear the Son of God. It also presents Mary's pious stature—her fear, her reluctance, and ultimately her humility and acceptance of God's will—all in the same frame.

As if this were not enough content, the icon (see fig. 5.6) also includes what happens after Mary's "yes" to God: the Son of God becomes incarnate by the Holy Spirit! This is shown by the dark blue nimbus or half-circle at the top of the icon, called the **heavenly vault**, which is symbolic of the Father's participation in sending His only begotten Son into the world (John 3:16). Jesus, the Son of God, comes into Mary's womb by the Holy Spirit, which is portrayed by rays extending from the heavenly vault, which "overshadow" her (Luke 1:35).

Two Crosses

Who is this Son of God and what will He do? Among other things, He will voluntarily ascend to the Cross in order to conquer death and renew fallen creation. Two crosses are prominent in this icon but might not be noticed at first glance. The first cross is made by the crossing of the archangel's greeting arm with his staff. Constas explains that "Gabriel announces, not simply the divine child's conception, but his voluntary submission to death and subsequent heavenly exaltation" (Phil. 2:9).[7]

The second cross is the cross-shaped spindle or shuttle in Mary's hand, which indicates her participation in that same sorrow: "The small cross seems to rest—without the weight it will soon acquire—on the Virgin's left knee, as if in anticipation of the incarnate Word, Who will lie there both as a child and a corpse."[8]

7. Constas, *Art of Seeing*, 111.
8. Constas, *Art of Seeing*, 112.

Ὁ ΕΥΑΓΓΕΛΙCΜΟC ΤΗC ΘΚΥ

Figure 5.7. The Annunciation, from the Greek Orthodox Church of the Annunciation in Milwaukee, Wisconsin

Unnatural Structures and Inverse Perspective

Notice that the structures contained in the Icon of the Annunciation seem to be angled in random directions, tipping and turning

Figure 5.8. Sixteenth-century Icon of the Annunciation, from the Pskov Museum in Russia

every which way. Iconography includes buildings and other structures as part of the earthly world in which historic events occur. However, they are presented in an alternate form that enables them to be lifted out of the limitations of proper angles and accurate dimensions into a new reality beyond. The Pskov Museum Icon of the Annunciation presents us with another excellent example of inverse perspective.

In natural art, shapes are larger in the front and smaller in the back to emphasize distance and dimension. Imaginary lines drawn from the angles of structures terminate at what is known as the vanishing point in the distance of the image. But here in the icon, the structures and footstools are wider in the back than the front. If one were to extend the lines that comprise Mary's throne and the two footstools, the vanishing point would reach forward rather than to the back of the work. The viewer becomes included in the scene, both as witness to and beneficiary of this good news. This unnatural perspective also offers a sense that the persons in the icon are moving forward to greet the viewer. The inverse perspective conveys an otherworldly perspective but also conveys that the action taking place—the Annunciation to Mary about the Incarnation of Jesus Christ—is not only for Mary's benefit but for all who gaze upon the icon with faith. In a sense, the icon "makes present" this reality for the spiritual benefit of the viewer.

Left to Right

As the Annunciation Icon is the first icon in this book that illustrates a progressive dialogue and sequential action, it is an appropriate example to introduce directional movement in an icon. The right side of the icon's plane figuratively represents the direction east, as on the right side of a map. The natural event of the daily rising of the sun from the east brings light into the dark world. Yet this natural rising of the sun can also be a symbol of the "Sun of Righteousness" (Mal. 4:2), Who comes from the east—"as the lightning comes from

the east and flashes to the west, so also will the coming of the Son of Man be" (Matt. 24:27).[9]

The same idea is applied to the reading or interpretation of an icon, as it guides the viewer's attention from left to right. The underlying notion is that this movement mirrors a journey from darkness to light, representing the Christian life as an ever-intensifying encounter with Jesus the Christ, who came to "give light to those who sit in darkness" (Luke 1:78–79).

9. The rising sun as a symbol of the "Sun of Righteousness" is the reason that most Orthodox churches face east.

6

The Nativity

Christ Is Born! Glorify Him!

Rather than the holiday greeting "Merry Christmas," Orthodox Christians greet one another with "Christ is Born!" and respond with "Glorify Him!" In addition to the historical event of the birth of Jesus establishing the child's humanity, the texts of Holy Scripture clearly reveal that this is no ordinary child. This is the birth of God's divine Son—the eternal Logos (John 1:1), the "Sun of Righteousness" (Mal. 4:2). The Nativity of Christ is thus a meeting of heaven and earth in which the eternal God enters time as a human baby. The Nativity is also an encounter between the Old Testament and the New—the prophetic expectations of the Messiah's coming have been realized in His Nativity.

The traditional story of Christmas, as depicted in most film versions and church Christmas pageants, combines the events from Matthew's and Luke's Gospels into a single narrative. Luke's shepherds and Matthew's **magi** are together at the scene of the newborn Jesus, despite Luke not mentioning magi and Matthew not referring to shepherds. The Orthodox Icon of the Nativity of Christ expands on this narrative, incorporating not only the shepherds and magi but

other elements. The scene depicts both the humanity and the divinity of the child and glimpses into earthly and heavenly reactions to His birth. Additionally, the icon refers to prophecies about the Messiah's coming and human lineage, and it even hints at future events, like the Cross and the empty tomb. The Nativity Icon is packed with rich meaning, making it one of the most robust in the Orthodox iconographic tradition.

The Icon

The Orthodox Icon of the Nativity may not resemble the typical Christmas card, like the one received last year from your Aunt Jenny and Uncle Bill. Where is the "Holy Family" in front of the charming A-frame structure? Why is Joseph so distant from Mary and the baby Jesus, and why does he appear so old? These questions will be answered as we explore the differences between Western religious art and Eastern Orthodox icons. Unlike Western representations, the Nativity Icon, like all icons in general, avoids romanticized or purely human elements, such as the portrayal of a chubby baby or a voluptuous Madonna. Despite this departure from Western norms, the Nativity Icon effectively conveys the joy and grandeur of the birth of the Savior of humankind with great clarity and simplicity.

In Western Christianity (Protestant and Roman Catholic), the Cross is often viewed as the central focus of Christ's redemptive work. However, the Bible emphasizes that the significance of Christ's coming predates the Cross and reaches into eternity. Centuries before His birth, the prophets foretold that the Son of God would enter the world as a human, carried in a woman's womb (e.g., Isa. 7:14). In the fourth century, the influential Gregory the Theologian (of Nazianzus) referred to Christmas as a festival "of re-creation,"[1] underscoring

1. Gregory the Theologian, Oration 38.4, "On the Theophany or Birthday of Christ," New Advent, https://www.newadvent.org/fathers/310238.htm.

ΗΓΕΝ ΝΗCΙC

By the hand of Tom Clark

Figure 6.1. The Nativity of Christ

that because of Christ's birth all creation acquires new significance. There are elements in the Nativity Icon that connect to the ancient prophecies of the Messiah's arrival and depict that anticipation of the renewal of creation. The Icon of the Nativity also portrays representatives from different walks of life, each rendering a unique offering to the newborn King.

Figure 6.2. Sixth-century Icon of the Nativity, from the Monastery of Saint Catherine in Sinai, Egypt

The Mountain and the Light

The ancient Christian tradition holds that Mary and Joseph were sheltered in something like a cave for the night. This is consistent with the earliest examples of the Nativity Icon (such as the sixth-century icon from Sinai) in which Mary and the Christ Child are shown in a cave of a mountain. The familiar A-frame shelter of contemporary Christmas cards did not appear in the religious art of the Nativity until around the late twelfth century in the Roman Catholic West.[2] All versions of the Orthodox Icon of the Nativity of Christ, however, are set in a cave on a mountain, following the earliest tradition.

Bethlehem is hilly, at about 2,500 feet above sea level, but it is not as mountainous as suggested by the prominence of the mountain range in the Icon of the Nativity of Christ (see fig. 6.3). The mountains in this icon represent more than natural geology. The mountain is often the place in Scripture where a theophany (an appearance or manifestation of God) occurs. Consider Moses's or Elijah's encounters with God on Mount Sinai. Moses encountered the Lord, the "I AM," in the burning bush at the top of Mount Sinai (Exod. 3:14). God told Elijah to climb Mount Horeb (another name for Mount Sinai), where he heard God's still small voice (1 Kings 19:11–12).

In Bethlehem, God was not only encountered on the mountaintop but came to be one of us. This is a theophany extraordinaire! The Prophet Habakkuk was given a vision of Israel's Messiah coming from the mountaintop: "God came from Teman, The Holy One from Mount Paran. His glory covered the heavens, And the earth was full of His praise. His brightness was like the light" (Hab. 3:3–4). Mount Paran, located to the east of Israel, symbolizes God's arrival from

2. Examples of A-frame structures in Renaissance art: *Nativity between the Prophets Isaiah and Ezekiel* by Duccio di Buoninsegna (1308–11) in the Washington National Gallery of Art, *The Nativity* by Piero della Francesca (ca. 1480) in the London National Gallery, and *The Nativity* by Giotto di Bondone (ca. 1303–10) in the Scrovegni Chapel.

Figure 6.3. Fifteenth-century Icon of the Nativity, from Gostinopolye Church of Saint Nicholas in Russia

the east, akin to the rising sun, bringing light into a dark world. At Christ's birth, a new day has dawned.[3]

3. The hymn of the Prophet Habakkuk is strikingly similar to Moses's blessing of the Israelites in Deut. 33:2: "The LORD came from Sinai, / And dawned on them from Seir; / He shone forth from Mount Paran."

The coming of the Messiah is also presented as sunrise and light in several biblical passages, such as from the Prophet Isaiah in the Old Testament:

> Arise, shine;
> For your light has come!
> And the glory of the LORD is risen upon you.
> For behold, the darkness shall cover the earth,
> And deep darkness the people;
> But the LORD will arise over you,
> And His glory will be seen upon you.
> The Gentiles shall come to your light,
> And kings to the brightness of your rising. (Isa. 60:1–3)

In the New Testament, Luke records the prophetic praises of Zacharias, the father of John the Baptist, who describes the coming Messiah as a divine sunrise: "Through the tender mercy of our God, With which the Dayspring from on high has visited us; To give light to those who sit in darkness and the shadow of death" (Luke 1:78–79). Therefore, the mountaintop of Christ's Nativity is truly a proper setting for a theophany. The dark cave is an appropriate setting for the universe itself, darkened by sin, to receive the "light of the world" (John 8:12). The use of light and dark holds even more theological significance in this context. The darkest area of the icon is the cave opening, while the brightest spot is the central focus: the crib and the divine baby, Who is Himself the "Sun of Righteousness" (Mal. 4:2). Whoever follows this Child "shall not walk in darkness, but have the light of life" (John 8:12).

Christian art scholar Fr. Stephen Bigham emphasizes that "light is the essence of iconography," and the purpose of icons is "to spread light."[4] Consequently, it becomes the task of the iconographer to visually express divine light. The role of the icon painter,

4. Stephen Bigham, "The Iconography of the Annunciation," *Sacred Art Journal* 17, no. 2 (Summer 1996): 12–23.

Figure 6.4. Late seventeenth-century Icon of the Nativity, from Crete

therefore, is not simply to create a religious image but to make spiritual truths visible, in line with the fullness of the biblical texts. This explains why iconographers strive to present the meaning of the gospel as accurately as possible in form and color, without skewing the image according to the natural world or to the painter's own ego.

It bears mentioning again that in the technical process of painting icons, lighter hues are painted over darker ones. Notice how, in this seventeenth-century Cretan icon, the brightest whites and ochers are used as highlights on the mountain, suggesting that Christ "the true Light" (John 1:9) has come to illumine all of creation. The technical process parallels the preparation of the iconographer as well as the increase of spiritual maturity in the Christian life.[5] The iconographer strives to keep Christ's light in mind in prayer as light details are being built up over the darker base, symbolizing the gradual revealing of God's glory as light. The Christian life itself is understood in Orthodox Christianity in this way—as a progression from the darkness of the world into the Light of Christ: "For you were once darkness, but now you are light in the Lord. Walk as children of light" (Eph. 5:8).

Mary, the Mother of God

Mary's importance cannot be overstated: she has given birth to the Savior of the universe. Mary therefore occupies a central place in this icon. Her size and placement illustrate the iconographic technique of **hierarchical perspective**, in which importance is indicated by both position and size.[6] She is shown outside the opening of the cave, reclining on a cot. It is likely that travelers would have brought a bed similar to this with them on their journey, which would hang from posts provided by the inn. Mary is looking away from the child she has

5. See chap. 1 under the heading "Reading and Writing Icons" and chap. 3 under the heading "Progressive Enlightenment."

6. Solrunn Nes, *The Uncreated Light: An Iconographical Study of the Transfiguration in the Eastern Church* (Grand Rapids: Eerdmans, 2007), 27.

Figure 6.5. Sixteenth-century Icon of the Nativity, from the Novgorod School in Russia

just borne, appearing calm and meditative. As Luke recounts: "Mary kept all these things and pondered them in her heart" (Luke 2:19).

The Baby and the Crib

The Christ Child is shown at the center of the icon and is depicted as the brightest element, receiving focus from the rays extending

By the hand of Michael Kapeluck

Figure 6.6. Nativity of Our Lord

Figure 6.7. Crib portion of a Nativity Icon

Figure 6.8. Tomb section from the Icon of the Myrrhbearing Women at the Empty Tomb (see fig. 11.6)

from the heavenly star. He is shown wrapped in swaddling clothes and lying in a manger, as indicated in Luke 2:7. This manger, typically a feeding trough for animals, forms another notable example of the altered perspective technique in icons. It employs an inverse perspective, where the lines from the manger converge forward toward the viewer, in contrast to the convention used in typical naturalistic art.[7] Furthermore, the baby and crib are often shown as if looking down from above, while everything else is represented from a front-facing viewpoint. The reason for the alteration of perspectives, as in all iconography, is to establish the historical setting of the event while simultaneously removing the temporal and physical boundaries of the event. In a way, the icon adds something like a fourth dimension, which is a glimpse into its cosmic reality.

Even as a baby, Jesus is often depicted with a cross in His halo since He has come to earth out of love for His creation to suffer willingly on the Cross for the salvation of the world. Together with the crib, this small cross symbolically connects the Messiah's birth to His purpose, representing not only His future suffering and death on the Cross but also His victory over death itself.

Jesus's bed in this icon appears nothing like a traditional crib. For that matter, it also looks nothing like a traditional manger! But it is actually a very important element of this icon that conveys the profound and cosmic realities of Christ's death, burial, and Resurrection. To explain, let us fast-forward thirty-three years or so in the life of Christ (and several chapters ahead in this book). On the morning of the third day after Christ's Crucifixion, women arrived at the tomb with myrrh and spices to anoint His body (Mark 16:1).[8] The second image inset is how the empty tomb is portrayed in the Icon of the **Myrrhbearing Women** at the Tomb. Quite noticeable is the intentional similarity between the iconographic depictions of the

7. See the description of inverse perspective in chap. 3 under the heading "Inverse Perspective."

8. See chap. 11 under the heading "The Myrrhbearing Women at the Empty Tomb."

cloths that wrapped the baby in the manger and the graveclothes left behind in the empty tomb.

Though the manger resembles a tomb, it should not be seen as a somber addition to the otherwise joyful Nativity scene. The significance lies not in the crib's iconographic similarity to the tomb but rather in the way the swaddling clothes are wrapped around the baby Jesus. The swaddling clothes of the Nativity Icon prefigure the graveclothes left behind (Matt. 27:59; Luke 24:12). The manger is therefore an incredibly joyful symbol anticipating the Lord's Resurrection and the empty tomb. Remarkable indeed is how the Icon of the Nativity is able to seamlessly convey the meaning of Christ's birth, death, and burial, and the triumph of His Resurrection, using only a halo, a manger, and cloth!

The Ox and the Donkey

In most icons depicting the Nativity of Jesus Christ, an ox and a donkey are shown near the crib. However, these animals are not mentioned in the narratives of Christmas by either Luke or Matthew. This leads to questions regarding why they are portrayed at all, and why they are positioned so close to the baby Jesus. This curiosity allows us to remember that icons usually do not include elements that are unrelated to the biblical truth, prompting a further exploration of their significance. As it happens, these two animals hold considerable importance in the grand narrative of the arrival of Israel's Messiah. In a way, the presence of these two humble animals shown together speaks volumes about the true message of Christ's gospel!

The Prophet Isaiah was granted a vision of the coming of the Messiah and prophetically announced that His coming would be recognized by these two animals: "The ox knows its owner, / And the donkey its master's crib; / But Israel does not know, / My people do not consider" (Isa. 1:3). These animals symbolize the prophecy of

Figure 6.9. Crib, donkey, and ox portion of an icon

the Messiah's coming and the rejection He will suffer as the suffering servant of God (see 42:1–4; 49:1–6; 50:4–7; 52:13–53:12).

Isaiah also foresaw that this Child would come to bring peace. The words "Prince of Peace" in Handel's Hallelujah Chorus, often sung at Christmas, are drawn directly from Isaiah 9:6. The imagery of Jesus as the Prince of Peace in the Nativity Icon finds its roots in the placement of the ox and the donkey together. This association would have been scandalous to observant Jews, in direct conflict with a specific Mosaic law that explicitly prohibited the pairing of ox and donkey: "You shall not plow with an ox and a donkey together" (Deut. 22:10). According to the dietary and ritual cleanliness laws outlined in the Old Testament, the ox is considered to be a "clean"

animal, while the donkey is classified as "unclean."[9] Per these laws, clean and unclean were never to be in close proximity to one another.

To fully appreciate the significance of these two animals, it is crucial to understand how important it was (and still is) for a ritually observant Jew to maintain this separation. An example is to be found in Saint Peter's vision of the clean and unclean meats placed together, described in the Acts of the Apostles 10:9–15. Even after Peter heard a voice instructing him to eat the "unclean" food, he initially objected by saying: "Not so, Lord! For I have never eaten anything common or unclean" (10:14). The vision of clean and unclean food was merely the first part of the lesson the Lord intended to teach Peter.

In an ancient Jewish mindset, the distinction between "clean" and "unclean" also extended to the differentiation between the chosen Jewish people and the Gentiles. Gentiles were considered "unclean," which (among other things) is the reason Gentile men could not enter the Jewish temple, instead remaining separated outside in the Court of the Gentiles. So the deeper lesson for Peter was not about dietary regulations but that God did not view people as unclean either. After meeting Cornelius, a righteous Gentile, Peter gained new insight and admitted: "You know how unlawful it is for a Jewish man to keep company with or go to one of another nation. But God has shown me that I should not call any man common or unclean" (Acts 10:28). Through this vision and encounter with Cornelius, Peter finally grasped that God accepted Gentiles alongside Jews as members of the Church.

This same emphasis is the intended symbolism in the Nativity Icon: the ox represents Jews, while the donkey represents Gentiles. The presence of both animals together signifies that this baby has the power to bring these two estranged groups together in peace and harmony.

9. According to Lev. 11:26, the donkey fits the category of unclean animals because it has cloven hooves and does not chew its cud. Regarding the ox and the ass, Philo of Alexandria, a first-century BC Jewish philosopher, affirms that "the ox is clean and the ass belongs to the unclean." Philo of Alexandria, "On the Virtues" in *Philo: Volume VII*, Loeb Classical Library 320, trans F. H. Colson (Cambridge, MA: Harvard University Press, 1939), 253.

Understanding the symbolism of the seemingly inconsequential pairing of two animals reveals a profound significance: the coming together of the clean and unclean (from a Jewish perspective) in worship of the Christ. It is worth noting that a similar intermingling of what may be considered clean and unclean is seen in the genealogy of Jesus presented in Matthew's Gospel. The inclusion of Gentile women like Ruth and even Rahab (Matt. 1:5), who was a harlot, highlights that the one true God of Israel recognizes the faith of religious "outsiders."

These examples further emphasize the inclusive nature of the gospel message. The Messiah brings ultimate peace, such that even those who are marginalized by the religious elites and those with enmity for one another are welcomed and saved together through Him. As we proceed through the remainder of this chapter about the Nativity Icon, we will observe that a category of people often considered unclean by observant Jews—the shepherds—will be the first to hear the "good tidings of great joy" (Luke 2:10) about the Savior's birth.

The Angels and the Shepherds

Because Israel's shepherds lived out in the fields, keeping watch over their flocks (Luke 2:8), they could not keep the details of the Jewish ceremonial law such as handwashing and other rules (1 Sam. 17:34–35; Lev. 5:1–13; 11). Even though they were often shunned by many religious Jews of their time, God determined that these simple men of the fields should be the first to receive the message of His Son's birth. There is also something of a perfect symmetry here, since those who cared for the lambs will become the first to worship the pure "Lamb of God" (John 1:29).

At first, a single angel appeared to convey the "good tidings of great joy" to the shepherds, and then a multitude of angels followed (Luke 2:9–13). The single angel is usually depicted on the right side of the icon, bending down toward the shepherds, while the multitude of the heavenly host is portrayed at the top. In many icons, one choir of angels is portrayed facing downward, delivering good news

Figure 6.10. Fifteenth-century Cretan Icon of the Nativity of Christ, from the Byzantine and Christian Museum in Athens, Greece

and attending to the earthly events, while another grouping is depicted facing upward, praising God. Additionally, certain icons include a shepherd playing a flute, through which human art (music) is added to the praises of the angels.

Luke describes how the shepherds did not delay, but "they came with haste and found Mary and Joseph, and the Babe lying in a

manger" (Luke 2:17). Afterward, they returned to their fields "glorifying and praising God for all the things that they had heard and seen, as it was told them" (2:20). In a meaningful way, the shepherds represent anyone with an earnest desire and simple faith who comes to the Lord without hesitation.

Joseph, the Protector

Allow me to address the initial question posed at the beginning of this section: Why does the icon portray Joseph as being so far from Mary and the baby Jesus, and why does he appear so elderly? Let us first remember how Jesus came to be the child of Mary: "The Holy Spirit will come upon you, and the power of the Highest will overshadow you; therefore, also, that Holy One who is to be born will be called the Son of God" (Luke 1:35). Very simply, Jesus does not have an earthly biological father. For this reason, we will find nothing like the concept of a Holy Family in the New Testament, nor in the early Apostolic and Patristic writings, nor in the Eastern Orthodox Christian tradition, either then or now.

The Holy Family became a popular subject of religious art in Roman Catholicism beginning in the late fifteenth century. Formal veneration of the Holy Family began in Roman Catholicism in the seventeenth century.[10] Eastern Orthodoxy, however, considers the concept of a Holy Family to be an overstatement at best and a theological error at worst.

Although Joseph was certainly an important figure in the Nativity story, he was not Jesus's biological father. This is the primary reason why Joseph is shown far away from the main activity of the Nativity Icon. His contribution to the birth of God's Son was as guardian and protector of Mary and Jesus. The threat was real since Herod

10. Formal veneration of the Holy Family began in the Roman Catholic world in the seventeenth century by a bishop named François de Laval, the first bishop of Quebec, Canada. See A. Leblond de Brumath, *The Makers of Canada: Bishop Laval* (Toronto: Morang & Company, 1912), 86.

ordered the murder of all the male babies and toddlers in Bethlehem solely to eliminate this one Child (Matt. 2:16).

Nevertheless, Joseph is described as righteous by Matthew (1:19), and therefore he is rightfully depicted in the icon with a halo. Joseph is also portrayed in iconography with graying hair, which is in line with the ancient Christian belief that Joseph was significantly older than Mary. This is supported by the absence of any mention of Joseph in the Bible beyond Jesus's twelfth year, when he and Mary discover Jesus teaching in the temple (Luke 2:42–51).

Despite being visited by an angel who explained, "that which is conceived in her is of the Holy Spirit" (Matt. 1:19–24), Joseph was in a state of turmoil, and the icon captures him not yet fully grasping the profound meaning of what is unfolding. The old man near Joseph, wearing animal skins and holding a staff, is the personification of temptation by the **Evil One** (the devil) bringing doubt and disbelief to Joseph's mind about the possibility of a virgin birth. According to Russian iconographer and art historian Leonid Ouspensky, the icon discloses not only Joseph's personal struggle "but the drama of all mankind—the difficulty of accepting that which is 'beyond words or reason'—the Incarnation of God."[11]

The Jesse Tree

> Let the heavens rejoice, and let the earth be glad;
> Let the sea roar, and all its fullness;
> Let the field be joyful, and all that is in it.
> Then all the trees of the woods will rejoice before the LORD.
>
> —Ps. 96:11–13 (95:11–13 LXX)

All creation rejoices in the glory of the Lord (Ps. 8:1) and shares in the praise and worship of the newborn King! Even the field and trees of the woods rejoice (96:13). This idea of nature participating

11. Vladimir Lossky and Leonid Ouspensky, *The Meaning of Icons* (Crestwood, NY: St. Vladimir's Seminary Press, 1982), 160.

By the hand of Michael Kapeluck

Figure 6.11. A portion of the Nativity Icon by the hand of Michael Kapeluck (see fig. 6.6)

in praises is depicted in the Nativity Icon through the arrangement of herbs and shrubs scattered throughout. Among these, there is always one tree that stands out, usually the largest tree in the icon, positioned directly below the Christ Child. This tree symbolizes Jesse, the father of King David, who had eight sons and two daughters. The Messiah was prophesied to arise as a shoot from Jesse's lineage: "There shall come forth a shoot from the stump of Jesse, and a branch shall grow out of his roots. / And the Spirit of the LORD shall rest upon him" (Isa. 11:1–2 RSV).

The Gospels of Luke and Matthew both contain genealogies of Jesus that are symbolic as well as historically accurate. Saint Matthew begins his Gospel with "the genealogy of Jesus Christ, the Son of David, the Son of Abraham" (Matt. 1:1) and traces the line of Jesus's legal father, Joseph (son of Jacob), from Jesse, through David and his son Solomon. In contrast, Saint Luke makes it clear at the beginning of his genealogy that Jesus was not Joseph's son "(as was supposed)" (Luke 3:23). Luke also traces Jesus's lineage from Jesse through David, but then through David's son Nathan, with no mention of Solomon. The purpose of the two genealogies is to demonstrate that Jesus was in the complete sense a descendant of both Abraham and David, with prophetic, priestly, and royal lineage.[12] With regard to the two genealogies, the fourth-century Saint Ambrose of Milan insists that "one agrees with the other in equal faith and truth."[13]

It is quite remarkable that the presence of this one tree in the icon can encapsulate a host of prophecies in a single visual element. It

12. *The Orthodox Study Bible*, commentary notes on Matt. 1:1, 6 (Elk Grove, CA: Saint Athanasius Academy of Orthodox Theology, 2008), 1266 (NKJV text copyright © 1982 by Thomas Nelson).

13. The views of Ambrose in this regard are summarized by Thomas Oden, *Ancient Christian Commentary on Scripture: Luke* (Downers Grove, IL: InterVarsity, 2003), 69–70. Oden includes the idea of unnamed commentators who suggest that Matthew offers Jesus's "royal descent" through His legal father, Joseph, and Luke offers the "priestly descent" through Mary's flesh and blood lineage through David's son Nathan, yet he suggests that a careful analysis makes it difficult to hold fast to the view that either genealogy exclusively refers to the royal or priestly descent.

serves as a powerful representation of Jesus's lineage, which aligns precisely with the prophecies concerning Israel's Messiah: He came from the stump of Jesse, and the Spirit of the Lord rests on Him (Isa. 11:1–2).

The Star and the Magi

The star is mentioned in Matthew's Gospel, but not in Luke's. This is the star that guided the "wise men from the East" (Matt. 2:1) in their journey. Ordinarily we can see stars in the night sky, but they appear quite distant. How, then, could one be followed? Matthew offers very specific details, stating that "the star . . . went before them, till it came and stood over where the young Child was" (2:9). In other words, this was no ordinary star, but a star imbued with intelligence! It was a star that moved with them—"a supernatural guide to lead the magi to Christ."[14] It was apparently not visible while they were with Herod, appearing again when they left Herod and stopping in the exact location of the house where they saw "the young Child with Mary His mother" (2:11).[15]

Saint John Chrysostom believes that it was not a star at all "but some invisible power transformed into this appearance,"[16] which is consistent with how it is portrayed in the icon—not simply a star, but something of a divine manifestation in the form of a star. Notice the ray of divine light that emanates from the spherical **vault** at the top of the icon. It originates beyond the boundaries of the icon, to address its heavenly origin. The ray extends directly toward the cave, ending just above the head of the infant Christ. At its midpoint, the ray expands and takes the form of a star.

14. Curtis Mitch and Edward Sri, *The Gospel of Matthew*, Catholic Commentary on Sacred Scripture (Grand Rapids: Baker Academic, 2010), 52.

15. See Dale C. Allison, "The Magi's Angel," in *Studies in Matthew: Interpretation Past and Present* (Grand Rapids: Baker Academic, 2005), 17–41.

16. John Chrysostom, "Homily 6 on Matthew," New Advent, https://www.new advent.org/fathers/200106.htm.

Figure 6.12. The Nativity of Christ

Not "Wise Men"

The "wise men," as they are often called, are usually shown in icons opposite the shepherds, and most often on the left side. They are opposite the shepherds in many ways. The shepherds came immediately to the child as soon as they heard the news of His birth. The wise men, however, took a circuitous route through study of the stars and a detour to meet with "Herod the King" (Matt. 2:1).

The Greek in Matthew's Gospel is very specific, however, that these are not actually "wise men" at all, but magi (Greek: *magoi/*μάγοι).[17] This is the same term used of Simon Magus in Acts who "practiced sorcery" (Acts 8:9–11), and the root of the word is where we get the word "magic." The magi were a particular class of Median and Persian priests who had a reputation in the Greek-speaking world for astrology and interpretation of dreams.[18]

The magi were Gentiles and would have been considered unclean by Jewish standards for that reason alone, but they were also rejected by the Jews because they were astrologers (Isa. 47:13–15) who looked to the stars—and to dreams—but not to the true God. Also, being Gentiles, the magi would not have been expected to honor the Jewish Messiah, and yet they did, setting up a theme that will be repeated in the Gospels: the most unlikely people follow Christ, while the religious elite reject Him.

This specific group of magi are typically rendered in the icon either as walking or on horses. They are also usually shown as various ages—one older, one younger, one in the middle. More than likely, the visit of the magi from Matthew's Gospel was a separate event, happening several months, if not a year or two, after Jesus's birth.[19] It

17. The Greek word *magoi* was first translated as "wise men" in the KJV translation of Matthew (2:1, 7, 16), perhaps to avoid the unpleasant idea that the visitors to Jesus were magicians.

18. Mitch and Sri, *Gospel of Matthew*, 50; David L. Turner, *Matthew*, Baker Exegetical Commentary on the New Testament (Grand Rapids: Baker Academic, 2008), 79.

19. "A comparison of 2:1 with 2:7, 16 indicates that the magi evidently arrived about two years after the birth." Turner, *Matthew*, 79.

was after their visit with Herod that he ordered all male children age two and under to be killed.[20] Because of their delay and distances, it is likely that Jesus was no longer a newborn infant by the time the magi arrived on the scene. Additionally, Matthew indicates that the magi came into a house and not to a manger: "And when they had come into the house, they saw the young Child with Mary His mother, and fell down and worshiped Him" (Matt. 2:11).

The number of magi is not mentioned in the Gospel, but the number of their gifts is three: "They presented gifts to Him: gold, frankincense, and myrrh" (Matt. 2:11). These specific gifts are also symbolic. The gift of gold is the sign that Jesus is the King of Israel, of the entire universe, and of the Kingdom of God to come. Jesus as Ruler is a crucial part of the Christmas story in the Gospels. This is also why Herod, out of fear that another would claim his throne, "put to death all the male children who were in Bethlehem and in all its districts, from two years old and under, according to the time which he had determined from the wise men" (2:16). The gift of frankincense signifies the fact that Jesus is God, since incense is used in worship, and only God may be worshiped. The gift of myrrh is for the Lord Jesus who has come to die as the perfect sacrifice for the people. The dead were anointed with myrrh, as Jesus Himself was to be anointed at the time of His death (John 19:39–40).[21]

The magi shown in the sixth-century Icon of the Nativity in figure 6.2 above are seen to the right of the manger. In certain icons, such as this one from the seventeenth century, there is also a single angel addressing them. This angel is the one who will appear to them in a dream warning them not to return to Herod (Matt. 2:12). The magi in this icon are also shown wearing crowns. However, the Bible does not suggest that

20. Herod the Great was generally evil and paranoid, especially near the end of his life, which is mentioned in Matt. 2:15. Herod is reported to have killed his wife, his mother-in-law, and his three oldest sons, fearing that they were conspiring to take his throne. See Mitch and Sri, *Gospel of Matthew*, 57.

21. Thomas Hopko, *The Winter Pascha: Readings for the Christmas-Epiphany Season* (Crestwood, NY: St. Vladimir's Seminary Press, 1984), 127.

Netelo / CC BY-SA 4.0 / Wikimedia Commons

Figure 6.13. Seventeenth-century Icon of the Nativity of Christ, located in the Hermitage Museum in Russia

they were kings. Instead, the crowns are a reference to Old Testament prophecies that describe worship of the Messiah by Gentile kings who will bring Him gifts: "Because of Your temple at Jerusalem, Kings will

bring presents to You" (Ps. 68:29), and "the Gentiles shall come to your light, and kings to the brightness of your rising" (Isa. 60:3).[22]

The magi in the Nativity story and in the icon have multiple layers of significance. The magi were outcasts from the Jewish religious system due to their Gentile status and association with astrology and sorcery. Despite this, they undertook a lengthy journey to find the newborn Messiah, an act that contrasts sharply with Herod's evil intentions. In the end, upon finding the child, they worshiped Him (Matt. 2:11). It is an example of something like divine symmetry, that the magi, who gained insights from the skies, were in a way "taught by a star" to worship the true "Sun of Righteousness" as proclaimed in the Orthodox hymn of the Nativity of Christ:

> Your nativity, O Christ our God, has caused the light of knowledge to rise upon the world. For therein the worshippers of the stars were by a star instructed to worship You, the Sun of Righteousness, and to know You as Orient from on high. Glory to You, O Lord. Glory to You, O Lord.[23]

The narrative surrounding the magi underscores the universal appeal of the Savior's birth and the profound impact it had on those who were traditionally marginalized or at odds with the existing religious and political power structures. They are prominently included in the Icon of the Nativity as a powerful testament to the inclusive nature of the gospel of Jesus Christ and the transformative power of encountering Him.

The Washing Scene

I have saved this element of the Nativity Icon—the so-called "washing" or "bathing" scene—for last because it is quite unusual. In the corner opposite Joseph, two women are depicted. One of them

22. Also "The kings of Tarshish and of the isles will bring presents; / The kings of Sheba and Seba will offer gifts" (Ps. 72:10).

23. "Hymn of the Nativity of Jesus Christ," trans. © 2007 by Fr. Seraphim Dedes, accessed December 1, 2024, https://dcs.goarch.org/media/m/dedes/en/me/m12/d25/ve/w/apolytikion1.pdf.

Figure 6.14. Fifteenth-century Russian Icon of the Nativity, from the Tretyakov Gallery collection in Moscow

appears older than the other and holds the naked baby Jesus in her lap. She is ready to wash Him in the basin of water in front of her. The younger woman stands next to the basin pouring water into it. In the icon by the hand of Tom Clark (fig. 6.12 above), she appears

to be testing the water first. The sleeves of both women are shown as rolled up, as they might be in this situation. The fact that Jesus is shown twice in the same icon is characteristic of the absence of the passing of natural time.

The washing scene began to appear in painted icons as early as the sixth century and perhaps even earlier. Most contemporary icons of the Nativity of Christ will include the washing scene. Nothing like this is mentioned in the New Testament, however.[24] Nevertheless, the reason for including it is scriptural, which is simply to emphasize the Incarnation—Jesus becoming human. The main theological point is that Jesus became like us in every way yet without sin (Heb. 4:15). Jesus condescended to this human custom of washing after birth, just as He condescended to circumcision on the eighth day after His birth, and to baptism by John in the Jordan River, even though He had no sins to be cleansed.

24. The second-century Protoevangelium of James (chap. 19) as well as another very early writing with Matthew's name in the title refer to the presence of two women who attended to Mary during the birth.

7

The Meeting of Our Lord in the Temple

✝

A Meeting of Old and New

According to the Jewish law, Jesus was brought to the temple by Mary and Joseph forty days after His birth. The touching event of the meeting between the infant Lord and His people, Israel, is recounted only in the Gospel of Saint Luke (2:22–39). In every sense, this event marks a meeting between the old and the new: the righteous of Jerusalem's temple meet their Messiah; the Old Testament meets the New Testament.

This event is directly related to the Jewish Passover, which is why Luke quotes from Exodus—"Every male who opens the womb shall be called holy to the LORD" (Luke 2:23; see Exod. 13:2)—to explain why Joseph and Mary have brought the child to the temple. As the people of Israel were leaving Egypt, an angel of the Lord struck the Egyptians with the tenth plague, which was the death of all the firstborn in the country. To escape the angel of death, the Jews were to slaughter a one-year-old lamb and spread its blood over their doorways. Upon seeing the blood, the angel would spare the homes

By the hand of Michael Kapeluck

Figure 7.1. The Meeting of the Lord in the Temple

and the firstborn Jewish children (Exod. 12:21–28). In giving Moses the regulations about Passover, the Lord God demanded that every

firstborn of Israel should thereafter be consecrated to the Lord God in memory of their flight to Egypt (Exod. 13:2) and brought to the temple on the fortieth day (Lev. 12:6–8).

The Icon of the Meeting of the Lord takes place in the temple in Jerusalem. The canopy in the background is a reference to the altar of the temple. Notice the iconographic attribute of the red cloth indicating that the action is taking place indoors. Again, this element would not be needed in natural art, where walls likely would have been shown to indicate an indoor location. In contrast to natural art, scenery such as buildings, plants, and so on are stylized in an unnatural way. The intention is not to eliminate the historical element, since after all God is revealed through history. Rather the intention is to infuse the natural world with an otherworldly dimension—the real world as transfigured by Christ.

As the movement, or activity, in icons typically progresses from left to right, Mary and Joseph are entering from the left, moving toward the right, where the elder Simeon stands holding Jesus. Mary's and Joseph's arms are covered and extended in offering. Notice that even as an infant, there is a cross in Jesus's halo. As we saw in the Icon of Christ the Giver of Light in chapter 3, the tetragrammaton "ICXC" (the first and last initials of Jesus Christ in Greek) is also present near Christ. The first and last initials for "Mother of God," "ΜΡ ΘΥ" (Greek: Μήτηρ Θεού/*Mētēr Theou*), are shown above Mary's head.

Simeon and Anna

Luke tells us that Simeon was "just and devout, waiting for the Consolation of Israel, and the Holy Spirit was upon him" (Luke 2:25). It had been revealed to Simeon by the Holy Spirit "that he would not see death before he had seen the Lord's Christ" (2:26). So on this day, Simeon was brought into the temple by the Spirit (2:27) and immediately took up the baby in his arms.

Figure 7.2. The Meeting of the Lord

The righteous Simeon is shown in the icon as having just re-
ceived the divine Child from His mother, Mary.[1] Simeon immediately
blesses God with a hymn of thanksgiving for letting him attain to
this day:

1. He would later be known in the Orthodox Church as "Simeon the Receiver
of God."

Lord, now You are letting Your servant depart in peace,
According to Your word;
For my eyes have seen Your salvation
Which You have prepared before the face of all peoples. (Luke
2:29–31)

Simeon's praises confirm his knowledge that this Child is the promised "light to bring revelation to the Gentiles" and the glory of God's people Israel (2:32).

Simeon is shown with a beard and long hair. He leans in to receive the Child, with his cheek resting tenderly against the Child's face. Simeon's expression is affectionate, if not also sorrowful, since he has been given knowledge from the Holy Spirit of the Child's future: "Behold, this Child is destined for the fall and rising of many in Israel, and for a sign which will be spoken against (yes, a sword will pierce through your own soul also), that the thoughts of many hearts may be revealed" (Luke 2:34–35).

Simeon's head appears somewhat larger than the heads of the others. Art with natural perspective uses size to reflect distance so that things that are closer to the viewer are rendered larger and things farther away are smaller. In icons, however, size points to emphasis, not perspective, so that the most important elements are rendered as the proportionately largest in the icon. According to the iconographic technique of hierarchical perspective, the exaggerated size of Simeon's head near the Christ Child tells us that the emphasis of the icon and the meaning of the event lies in the meeting of the two: Simeon, who represents the expectation of the Old Testament, and the Messiah, Whose coming comprises the entire content of the New Testament.

Also present is the Prophetess Anna, "the daughter of Phanuel, of the tribe of Asher . . . a widow of about eighty-four years, who did not depart from the temple, but served *God* with fastings and prayers night and day" (Luke 2:37). The Prophetess Anna is shown standing either behind Simeon or behind Mary; both versions are shown here.

Anna is identified in the icon as a prophetess by the scroll she is holding. She points to the child to indicate her recognition that He is the long-awaited Messiah. Although both Simeon and Anna are considered to be the last of the Old Testament prophets, Anna also becomes one of the first New Testament evangelists since "she gave thanks to the Lord, and spoke of Him to all those who looked for redemption in Jerusalem" (Luke 2:38).

The Offering of Mary and Joseph

Being faithful to the law as described in Leviticus (12:6–8), Joseph and Mary have brought an offering: "a pair of turtledoves or two young pigeons" (Luke 2:24). The actual prescribed offering in Leviticus, however, is a one-year-old lamb (Lev. 12:6).

The offering of two turtledoves or pigeons would be acceptable from a family who could not afford the lamb (Lev. 12:8), and one might assume this was the case with Mary and Joseph. However, Mary's hands are shown extended and covered with cloth in most versions of this icon, which is a symbol of humble supplication and offering. This means that Mary has made an offering of a lamb after all—her child, Jesus: "the Lamb of God who takes away the sin of the world" (John 1:29).

Unique Style, Same Message

This sixteenth-century icon in the Russian Novgorod style portrays this same event. However, it is rendered in a style that differs from Byzantine-influenced icons. The background color here is a teal blue, rather than the gold or ocher of the Byzantine style. The red drape is shown as a cloth hanging from a structural pedestal at the left, rather than as a drape across the back. Nevertheless, this Icon of the Meeting of Christ in the Temple includes the same five people in the temple, it follows the same rules of iconography, and it includes the same attributes (two doves, Anna's scroll, covered hands). The colors of the

Figure 7.3. Sixteenth-century Icon of the Meeting of the Lord, Novgorod School in Russia

garments are also quite similar in all three versions of the icon presented in this chapter. The differing style, nevertheless, communicates the same gospel message and illustrates almost literally (in this case) the Gospel account of the Meeting of the Lord in the Temple.

The differences between the icons speak to the fact that each iconographer adds his or her own creative talents and personal style

while visually rendering the same event. Icons are not meant to be identical facsimiles of one another. We might liken the different iconographers to the four Evangelists, Matthew, Mark, Luke, and John, each of whom has conveyed aspects of the same events of the life of Christ yet has not written an account that is identical to the others' work. Each Evangelist drew upon his own talents and gifts, writing in his own unique linguistic and literary style, and adapting the gospel message to his specific audience.

Although their styles are different, Matthew, Mark, Luke, and John did not add extraneous or creative flourishes that would detract from the message being conveyed. Similarly, the iconographer, writing the gospel in form and color, does not add extraneous or creative flourishes from his or her own ego, which would detract from the scriptural message. The iconographic tradition leaves room for an iconographer's personal style to influence the presentation without overshadowing the message.

<div align="center">

8

The Baptism of Christ

</div>

The Beginning of Christ's Ministry

The event of Jesus Christ's Baptism in the River Jordan is recorded in all three **Synoptic Gospels** (Matt. 3:13–17; Mark 1:9–11; Luke 3:21–22) and marks the formal beginning of His earthly ministry at about thirty years old. Although the Son of God came into the created world at Christmas, He becomes known in a new way at His Baptism. As Saint John Chrysostom writes, "Before the day of Baptism he was not known to the people."[1]

The Baptism of Christ is also considered to be the proper **Theophany**, or manifestation of God, because during this event the three Persons of the Holy Trinity—Father, Son, and Holy Spirit—were revealed. The Trinity is symbolized by the three connected rays that extend from the semicircular heavenly vault. Jesus is seen bodily emerging from the waters of Baptism. As He "came up" from the water, the heavens opened, and He saw "the Spirit of God

1. John Chrysostom, "Discourse 37: On the Baptism of our Lord at Epiphany," quoted in Vladimir Lossky and Leonid Ouspensky, *The Meaning of Icons* (Crestwood, NY: St. Vladimir's Seminary Press, 1982), 165.

By the hand of Michael Kapeluck

Figure 8.1. The Baptism of Christ

descending like a dove and alighting upon Him" (Matt. 3:16; similarly, Mark 1:10; Luke 3:22).[2] The Father's voice was immediately

2. Jesus is thus the "Anointed One," which is the literal meaning of the Greek term *Christos* (Christ) and the Hebrew term *Mashiach* (Messiah).

heard acknowledging Him as the Son of God: "This is my beloved Son, in Whom I am well pleased" (Matt. 3:17; similarly, Mark 1:11; Luke 3:22).[3]

As with the Icon of the Meeting of the Lord in the Temple, this icon offers a largely faithful representation of the three Gospel accounts of Christ's Baptism. However, it also incorporates additional details not found in the Gospel accounts. For instance, the presence of angels on the right bank are not mentioned in the scriptural account of Christ's Baptism, although they will serve an important role ministering to Christ immediately following His Baptism when the Spirit leads Him into the wilderness: "And He was there in the wilderness forty days, tempted by Satan, and was with the wild beasts; and the angels ministered to Him" (Mark 1:13).

John the Baptist

Saint John the Baptist is depicted in the icon standing on the left bank, humbly bending forward to baptize Jesus (Mark 1:9) with His right hand extended over Jesus's head. John, who is also called the Forerunner, preceded Christ in ministry as well as in death.[4] He is always shown pointing the way to Christ, as illustrated in the icon with his left hand extended toward Jesus.

John the Baptist came onto the scene preaching **repentance**: "Repent, for the kingdom of heaven is at hand!" (Matt. 3:2). This aspect of John's ministry is captured in the icon by the ax shown at the base of the tree behind him, symbolizing the urgency of repentance in his preaching: "Even now the ax is laid to the root of the trees. Therefore every tree which does not bear good fruit is cut down and thrown into the fire" (Matt. 3:10; Luke 3:9).

3. Because this is the first time the Holy Trinity is fully revealed, the Orthodox Church refers to the Great Feast of Christ that celebrates this event as Theophany.
4. John was beheaded by Herod. See Matt. 14:1–11; Luke 3:19–20; 7:18–27; 9:9.

Photo: Fr. Ted Bobosh

Figure 8.2. The Baptism of Christ, by the hand of Dmitry Shkolnik, from St. Paul Orthodox Church in Dayton, Ohio

Jesus and the Jordan River

Even though John is the officiant of the baptismal rite, so to speak, the icon reflects that it is Jesus Who is blessing the waters of the Jordan River with His right hand.[5] By the blessing of the Creator Himself, the waters of the Jordan have become transformed into holy waters. The banks of the river are rendered in the icon in a stylized manner with jagged borders to situate the event simultaneously within time and beyond time in the divine realm of eternity.

Given that "immersion" is the proper meaning of the Greek word for "baptism" (*baptisma*/βάπτισμα), the icon also portrays Jesus as though He is standing, yet fully immersed in these waters. He is shown as a physically strong man and, in most icons of this event, depicted as nearly naked. In some older icons, as in this eighteenth-century Russian icon, Jesus is rendered as fully naked as a specific reference

5. As was discussed in chap. 3 with regard to the Icon of Christ the Giver of Light, Jesus is making the initials of Jesus Christ in Greek (ICXC) with His right hand.

Figure 8.3. Eighteenth-century Icon of the Baptism of Christ, from the Volga Region of Russia

to the contrast Saint Paul makes between two Adams in his First Letter to the Corinthians.[6] The first Adam hid when his sin revealed his nakedness (Gen. 3:10). In contrast, the "second Man" or "last Adam" is revealed unashamed in His glory as perfect God and sinless man.[7]

The Jordan River is naturally a rather calm body of water. Yet in the icon the waters of the Jordan are depicted as tumultuous. This

6. "The first man Adam became a living being. The last Adam became a life-giving spirit" (1 Cor. 15:45).
7. "The first man was of the earth, made of dust; the second Man is the Lord from heaven" (1 Cor. 15:47). Jesus is without sin (2 Cor. 5:21; Heb. 4:15).

Figure 8.4. Theophany of our Lord

symbolism is rooted in the belief that all creation—even an inanimate object like water—recognizes and praises its Creator. This belief is

reinforced by the words of Jesus Himself, who spoke of the possibility of creation praising Him: "I tell you that if these should keep silent, the stones would immediately cry out" (Luke 19:40).

The psalmist sees prophetically that the Jordan River recognizes the Lord:

> What ails you, O sea, that you fled?
> O Jordan, that you turned back? . . .
> Tremble, O earth, at the presence of the Lord,
> At the presence of the God of Jacob. (Ps. 114:5, 7)[8]

As Jesus sets foot in the Jordan and blesses it, the iconographic tradition conveys this same sense of the waters themselves being excited to recognize their Creator, by showing them in an agitated state. Here the waters of the Jordan are diagonal, while in the contemporary icons the water is pictured with elaborate swirls. Some icons additionally include two figures beneath Christ, as personifications of the waters of the sea, and the waters of the river. This aligns with the same Psalm: "The sea saw it and fled; / Jordan turned back" (Ps. 114:3; 113:3 LXX).

The Human Condition Is Baptized

A reference to Genesis may seem unexpected here, but it is essential to understand that in the ancient Christian world and for Eastern Orthodox Christians today, the Baptism of Christ represents more than a rite for an individual person. It symbolizes the renewal and purification of the entire human condition, and even of all creation. The fourth-century Saint Gregory of Nyssa expresses well the Orthodox view that Christ received baptism for the sake of His creation: "Today He is baptized by John that He might cleanse him who was

8. This is Ps. 113:5, 7 in the third-century BC Septuagint Text (LXX) and Ps. 114:5, 7 in the tenth-century AD Hebrew Masoretic Text (MT).

Figure 8.5. Mosaic Icon of the Baptism of Christ in the Jordan, from Saint Paul Greek Orthodox Church in Irvine, California

defiled, that He might bring the Spirit from above, and exalt man to heaven."[9]

Although this is a highly simplified summary,[10] the Orthodox view of "the Fall" focuses on the observable fact that human beings willingly turned away from the Source of Life itself (Gen. 3:3, 6). As a result, all creation has become subject to death, decay, and corruption.

9. Gregory of Nyssa, "On the Baptism of Christ," New Advent, https://www .newadvent.org/fathers/2910.htm.

10. For greater detail on the Orthodox understanding of the Fall and renewal in Jesus Christ, see Eve Tibbs, *A Basic Guide to Eastern Orthodox Theology: Introducing Beliefs and Practices* (Grand Rapids: Baker Academic, 2021), 99–124.

But the Savior came and took to Himself every aspect of our fallen nature—a decaying and corrupt humanity separated from the God of Life—and restored it to communion with His Father in His incarnate, human and divine, self. Now, in His Baptism, Jesus takes the created matter of humanity into the River Jordan to be baptized, offering creation the possibility of a nature renewed in Him.[11] Saint Athanasius of Alexandria writes, "When He is baptized, we it is who in Him are baptized."[12]

The Three R's: Repentance, Renewal, Revelation

The event of Christ's Baptism, as it is described in Scripture and as it is depicted in the icon, reveals three important Christian truths: repentance, renewal, and revelation. Repentance is shown by the ax that reflects the preaching of John the Baptist and Jesus Christ: "Repent, for the kingdom of heaven is at hand" (Matt. 3:2; 4:17). Renewal of creation is shown in the blessing of the waters of the Jordan and the extension of the benefits of Christ's Baptism to those who "put on Christ" through Baptism (Gal. 3:27). Revelation is shown by the visible Son, the Father's voice as rays descending from the heavenly vault, and the Holy Spirit appearing in the form of a dove as confirmation of the Father's word.

11. "For as many of you as were baptized into Christ have put on Christ" (Gal. 3:27). Our human nature has been renewed by participation in Christ's divine nature: "Through these [promises] you may be partakers of the divine nature, having escaped the corruption that is in the world" (2 Pet. 1:4).

12. Athanasius of Alexandria, "Discourse 1 Against the Arians," New Advent, https://www.newadvent.org/fathers/28161.htm.

9

Ministry, Discipleship, and Revelation

The Samaritan Woman at the Well

The oldest icon that visually presents the encounter between Jesus Christ and the Samaritan woman at the well (John 4:1–42) dates to the fourth century. It is found in the Catacomb of the Via Latina in Rome and is shown on the next page (fig. 9.1). In this section, I am also presenting three more versions of the same icon. Despite spanning many centuries and exhibiting diverse styles and colors, all the icons in this collection are remarkably similar in the scriptural details portrayed.

According to the Gospel of Saint John, Jesus and His disciples were traveling from Judea to Galilee, passing through Samaria. The account unfolds in a town called Sychar, near the well that the patriarch Jacob had given to his son Joseph (John 4:5). John also provides the time of day: "about the sixth hour" (4:6). The hours were counted from the rising of the sun, so the sixth hour would have been midday. We read that Jesus was weary from His journey and rested near the well while the disciples ventured into the town for food. While Jesus sat, "a woman of Samaria came to draw water" (4:6–8).

Public Domain / Wikimedia Commons

Figure 9.1. Fourth-century Icon of Christ and the Samaritan Woman at the Well, from the Catacomb of the Via Latina in Rome

Photo: Fr. Stephen Callos

Figure 9.2. Samaritan Woman at the Well, by the hand of Laurence Manos, from Saints Constantine and Helen Greek Orthodox Church in Cleveland Heights, Ohio

The well is the central visual element of the icon. The icon shows Jesus sitting near the well, on the left. The Samaritan woman is depicted on the right side of the well holding a water vessel in one hand. They face one another, emphasizing encounter (see fig. 9.2).

As is typical in an icon, the narrative action proceeds from left to right[1] when Jesus initiates the encounter by asking the woman for a drink (John 4:7). Jewish men did not normally speak to women in public, which is why the surprised woman asks why He has done this: "'How is it that You, being a Jew, ask a drink from me, a Samaritan woman?' For Jews have no dealings with Samaritans" (4:9).

Jesus does not respond to her question in the context in which she asked it—that is, the relationship between Jews and Samaritans. Rather, Jesus explains that His request of water is really a gift to her: "If you knew the gift of God, and who it is who says to you, 'Give Me a drink,' you would have asked Him, and He would have given you living water" (John 4:10). Not grasping that Jesus is referring to something far more significant than a drink of water by His offer of "living water," the woman continues speaking about less significant issues, such as the depth of the well, Jacob, his sons, and their livestock (4:11–12).

John has recorded another time when Jesus made the offer of living water: "If anyone thirsts, let him come to Me and drink. He who believes in Me, as the Scripture has said, out of his heart will flow rivers of living water" (John 7:37–39). The actual gift Jesus is offering the Samaritan woman is the life-giving refreshment of God's grace—a gift only He can offer. The icon makes it clear that this gift is not only for the Samaritan woman. Although in the icon the two face one another as they did on that day, they both also face the viewer. This portrayal is intentional to include the viewer as a potential recipient of the same gift offered by Christ to the woman. Those who recognize and embrace Jesus as the "gift of God" are granted the invitation to seek the same "living water" (4:10).

1. See chap. 5 under the heading "The Union of Heaven and Earth."

Public Domain / Wikimedia Commons

Figure 9.3. Thirteenth-century Icon of the Samaritan Woman at the Well, from Protaton Church in Mount Athos, Greece

Other Imagery

The icon is relatively simple with only two people, a well, and buildings; yet a grander narrative is at play in the exchange between Jesus and the woman. Samaritans were neither Gentile nor Jewish, but the Jews considered them to be religious enemies and unclean. In biblical imagery, the foreigner who engages in worship of false gods is likened to a harlot. Consider Exodus 34:12–16, which says in part: "lest you make a covenant with the inhabitants of the land, and they play the harlot with their gods and make sacrifice to their gods." Proverbs also warns of an "immoral woman" (Prov. 5:3). The wise man is counseled to avoid her and specifically cautioned against accepting water from her: "Drink water from your own cistern, / And running water from your own well" (5:15).

Figure 9.4. Christ Speaking to the Samaritan Woman

The Samaritan woman described by John and portrayed in the icon shares much with the women warned about in Proverbs and Exodus. Not only does she represent a foreign people who worship differently and are considered unclean by Jews; she also personally exhibits morally questionable behavior. As Jesus points out, she has had five husbands "and the one whom you now have is not your husband" (John 4:18).

Figure 9.5. Samaritan Woman at the Well, from Mount Athos, Greece

The woman's dubious history is illustrated in many such icons (though not all) by the absence of a head covering, which a modest woman would certainly have been wearing. An additional striking element of the icon is that this woman is nearly always portrayed as standing higher than the sitting Jesus, with her head shown higher than His head. This speaks to a boldness—or even brazenness—not typical either of a Samaritan or of a respectable female in the presence of a Jewish male.

The Samaritans were monotheistic worshipers of Yahweh and shared many similarities with Jews, including observance of the Sabbath, circumcision, and celebration of the religious festivals mentioned in the Pentateuch. What mainly differentiated Samaritans from Jews was their temple at Mount Gerizim. In the Gospel account, it is the Samaritan woman who first refers to the Samaritan temple when she

Figure 9.6. Mosaic Icon of Christ and the Samaritan Woman, from Saint Paul Greek Orthodox Church in Irvine, California

Figure 9.7. Icon of Christ and the Samaritan Woman at the Well, from a 1684 Arabic manuscript of the Gospels

asks Jesus where people should worship: "Our fathers worshiped on this mountain, and you Jews say that in Jerusalem is the place where one ought to worship" (John 4:20). This is the reason that the temple figures so prominently in the icon behind the woman. What separated Samaritans from the Jews was not that they believed in a different God but rather that their worship was not adequate, as Jesus declares with authority: "You worship what you do not know" (4:22). Further in their discussion, the woman admits she is waiting for the Messiah (4:25), and Jesus informs her that "I who speak to you am He" (4:26).

We are given glimpses into their dialogue and can only assume more was spoken in the exchange. What is abundantly clear, however, is that the woman's ethnicity as a Samaritan, contemptible to Jews, and her many indiscretions were not hindrances to the loving mercy of the Lord. He blesses her in His own Name as shown with His right hand.[2] Jesus has removed the boundaries between her people, the Samaritans, and the Jewish people; the door to His Kingdom is wide open to both. The woman's hand is depicted as upward, as a sign of interest in what Jesus is offering. By accepting the "living water" Jesus offers, the Samaritan woman becomes not only a disciple of Christ but also an evangelist. After this encounter with the Lord, she returns to her people and preaches the gospel throughout Samaria: "And many of the Samaritans of that city believed in Him because of the word of the woman who testified, 'He told me all that I ever did'" (John 4:39).

Many icons portraying this encounter render the well in the shape of the Cross of Christ, since the "living water" (John 4:10) that Jesus offers the Samaritan woman and all people is associated with the waters of Baptism and "a fountain of water springing up into everlasting life" (4:14). For this reason, baptismal fonts in many early churches were formed in the shape of a cross. Some icons render the well in the shape of a hexagon, relating to two elements of the Gospel account: the time of day (sixth hour) and the number of men she has lived with: six, including the present man.[3]

Afterword

There is an important "afterword" to this story that is not recorded in the Gospels. The primitive Christian tradition has passed along its knowledge of this Samaritan woman at the well, who received

2. His fingers form the letters ICXC, the first and last initials of the name Jesus Christ in Greek: Ἰησους Χριστός.

3. Jonathan Pageau, "The Samaritan Woman, Baptism, and the Hexagon," in *Orthodox Arts Journal* (July 11, 2015), https://orthodoxartsjournal.org/the-samaritan-woman-baptism-and-the-hexagon/.

Figure 9.8. Saint Photini Preaching, by the hand of George Kordis, from the Chapel of the Greek Orthodox Metropolis of San Francisco Heritage Center

the "living water" in Christian Baptism after Christ's Resurrection. She took the baptismal name of Photini, meaning "the enlightened one." Photini preached the gospel not only in Samaria but also in North Africa and Rome, where she was tortured and ultimately killed by Emperor Nero, after she led his daughter and her servants to Christianity.[4]

4. Bishop Demetri Khoury, *A Cloud of Witnesses: Saints and Martyrs from the Holy Land* (Bloomington, IN: Author House, 2008), 316–19.

By the hand of Michael Kapeluck

Figure 9.9. Saint Photini, "Equal to the Apostles"

Ironically, the last of Photini's many tortures on account of her faith in Christ was being thrown down a dry well. Saint Photini is remembered annually in the Orthodox Church on August 6, the day she entered eternal life. She is also honored with the title "Equal to

the Apostles" because of her boldness to proclaim the gospel of the Messiah, Whom she met at Jacob's well.[5]

Christian martyrs—those who were killed because of their faith in Jesus Christ—are identified in icons holding a Cross in their right hand. Often something that represents an element of their specific witness to Christ is also depicted in the icon. An example of this in the Icon of Photini is a water pitcher, symbolizing her encounter with Jesus Christ at the well and the blessing of "living water" that she received from Him. As with the Icon of Saint John the Forerunner in chapter 4, the Icon of Saint Photini records elements of her earthly life, her martyrdom, and her glorified status as a saint in Christ's heavenly Kingdom.

Christ Calming the Storm at Sea

All three Synoptic Gospels narrate the account of Jesus calming a raging storm on the sea (Matt. 8:23–27; Mark 4:35–41; Luke 8:22–25). Although the **pericope** is relatively short, spanning only four to seven verses, its vivid imagery and instructive nature make it a compelling event. If one were to portray the narrative in a storyboard format, it would require at least four or five panels to capture the sequence. However, the icon encapsulates the entire story on a single plane. The setting, as portrayed in the icon, is clearly that of a powerful storm engulfing the boat in which Jesus and His disciples are crossing the Sea of Galilee. While the depiction of the waves is not naturalistic, they are unmistakably waves, portrayed in an agitated state fiercely crashing against the small boat. The shores of the lake are also depicted in a stylized manner of unnatural sharp angles.

Within the storm, some of Christ's disciples can be seen attempting to navigate the vessel by adjusting sails—or perhaps holding on tightly for dear life! Amid the chaos, Jesus remains peacefully asleep

5. Khoury, *Cloud of Witnesses*, 316–19.

Figure 9.10. Icon of Christ Rebuking the Sea, from the Dionysios Monastery on Mount Athos in Greece. The Greek heading of this icon reads, "Jesus Christ rebuked the sea."

in the same boat that is being tossed about. As is typical in iconography, the boat is moving from left to right.[6] It is Saint Mark who offers the specific detail that Jesus was asleep "in the stern" (Mark 4:38). And it is at the left side of the boat, in the stern, where we find the sleeping Jesus. One of His disciples is depicted with raised arms, imploring Jesus to awaken and rescue them from impending

6. As previously mentioned, icons typically follow the rule of movement from left to right. This follows the natural reading direction of the New Testament in its original Greek form. Furthermore, this directional flow in icons expresses the gradual illumination and growth in the Christian life toward the east. The light of the sun comes from the east, as will the Son in His glory: "For just as the lightning comes from the east and flashes even to the west, so will the coming of the Son of Man be" (Matt. 24:27).

Figure 9.11. Icon of Jesus Calming the Storm, in the Gallery of Frescoes at the National Museum in Belgrade, Serbia

danger: "Teacher, do You not care that we are perishing?" (4:38). Jesus awakened and "rebuked the wind," calming the sea with His hand outstretched: "Peace, be still!" In some versions of this icon, as in the icon from the Dionysios Monastery, the wind is personified in the form of an imp, shown at the top left bank of the sea, toward which Jesus's attention and rebuke is directed.

In most versions of this icon, Jesus is shown twice in the same icon: peacefully asleep and also awake, responding to the disciples' plea for help. The artistic technique of **dual representation** is not exclusive to this particular icon.[7] This approach allows icons to capture the entirety of a significant biblical event, going beyond a single moment in time.

7. For example, in the Nativity Icon discussed in chap. 6, Jesus is shown in the manger in one place and being washed by the midwives in another place. Other examples include versions of the Transfiguration and the Feeding of the Five Thousand later in this chapter.

In the specific case of the Icon of Jesus Calming the Storm, it is not simply a snapshot of either the moment He is asleep or the moment He calms the storm. Instead, this icon serves as a pictorial representation of both actions of the biblical narrative, presented in the same frame.

The icon from the National Museum in Belgrade shares many of the same elements and attributes as the other icon, yet in a very different style. The main difference is the absence of the personified wind imp. Also, the sails and the sleeping Jesus on the right (at the back of the boat) mean that the boat is moving from right to left, which is not typical in iconography. The disciples' subsequent state of mind after this miraculous sign is also reflected in the face and posture of the disciple at the bow: "And they feared exceedingly, and said to one another, 'Who can this be, that even the wind and the sea obey Him!'" (Mark 4:41).

The Feeding of the Five Thousand

The Feeding of the Five Thousand is the only miracle of Christ presented in all four Gospels (Matt. 14:13–21; Mark 6:32–44; Luke 9:10–17; John 6:1–13). The situation leading up to this event was that Jesus initially tried to find a remote area to be alone, but thousands of people followed Him into that "deserted place" (Matt. 14:13). Moved by compassion, Jesus nevertheless healed the sick people who were brought to Him (Matt. 14:14), and He "began to teach them many things" (Mark 6:34).

The crowd was actually huge. According to Matthew and Luke, "five thousand" was the count of men (Mark 6:44, Luke 9:14), "besides women and children" (Matt. 14:21). As time passed and evening approached, the disciples suggested that Jesus send the multitudes away to find food for themselves in the villages. However, Jesus challenged them: "They do not need to go away. You give them something to eat" (Matt. 14:15–16). This is the point where the icon takes up the narrative.

Figure 9.12. Feeding of the Five Thousand

The first version of this icon, by the hand of Michael Kapeluck, utilizes the technique of "dual representation" and depicts Jesus

Christ in three places, moving from left to right, according to the progression of the narrative in the Gospels. In this way, the icon conveys the entire biblical pericope on a single panel. In all three places in the icon, Jesus is portrayed similarly, yet with differences in His gestures. As is typical, Christ's inner robe is depicted in red and His outer robe in blue, symbolizing His dual nature: red representing humanity and blue representing divinity. A cross is always present in the halo of Christ, bearing the same words spoken to Moses from within the burning bush: ὁ ὢν or the "I AM" (Exod. 3:14). The abbreviation for His name (Jesus Christ/Ἰησοῦς Χριστός) in Greek is always denoted by the four Greek initials (ICXC) shown to the left and right of Christ's head.

In the lower left corner of the icon, the disciples are shown as having returned with a report that they have only five loaves and two fish. Jesus instructs them to bring the food to Him, and then He directs all the people to sit down in groups on the "green grass" (Mark 6:39) as depicted in the icon. John's Gospel account offers the specific detail that it was Andrew who informed Jesus that a young boy had offered his five barley loaves and two fish. In the icon, one of the three individuals with Jesus is noticeably younger and represents the "lad" mentioned in John 6:9. Jesus is shown as blessing in His name with His right hand.

Moving from bottom left toward the top right, we encounter the largest image of Christ at the center of the icon. Again, hierarchical perspective (size according to importance) is used to draw attention to the important elements of the narrative. The largest central image of Christ shows Him multiplying the offering: "Looking up to heaven, He blessed and broke and gave the loaves to the disciples; and the disciples gave to the multitudes" (Matt. 14:19).

To the left and right of the central focus, Jesus's disciples are distributing the meal to the multitudes. The people are shown as receiving the offered food with outstretched open hands. Not only were all the people fed, but there were also abundant leftovers—twelve baskets full (Matt. 14:20), symbolizing the twelve Apostles. In the lower right

Figure 9.13. Mosaic Icon of Christ Feeding the Five Thousand, from Saint Paul Greek Orthodox Church in Irvine, California

corner of the icon, one disciple is adding the leftovers into the twelve baskets. Another disciple is shown with his hands covered—a symbol of supplication and offering in icons. He is offering the remains to Jesus, Who receives the offered remnant.

The mosaic mural panel exhibits a different style from the painted version, yet other than Christ being shown only once, the elements are nevertheless quite similar. Christ is blessing the five loaves and two fish, which are simultaneously being distributed by the disciples to the people, who have been instructed to be seated in groups on the grass. The disciples on the left of the icon are shown again with hands respectfully covered as they return the remnants of the feast to Christ, as an offering.

The Transfiguration

The event in Christ's ministry when He was transfigured before His three disciples is presented in all three Synoptic Gospels (Matt. 17:1–8; Mark 9:2–8; Luke 9:28–36). It holds great significance for Orthodox Christians, especially due to what is conveyed by its iconic depiction. The event is traditionally understood as having taken place on Mount

Figure 9.14. Seventeenth-century Icon of the Transfiguration, from the Dionysios Monastery on Mount Athos in Greece

Tabor. The label at the top of the seventeenth-century icon refers to the biblical event as "The Metamorphosis" in Greek (Ἡ Μεταμόρφωσις/*Hē Metamorphōsis*). This visually rich panel focuses on the transfigured Christ, but also on the events leading up to and following His Transfiguration, aligning with the accounts found in Scripture. The icon utilizes the technique of dual representation in which Jesus

Figure 9.15. Sixteenth-century Icon of the Transfiguration, from the Spaso-Preobrazhensky Monastery (now the Yaroslavl Art Museum) in Russia

and His disciples are shown in multiple places, and it follows the typical left-to-right movement to illustrate the progression of events.

Jesus is shown at the far left, leading the disciples of His inner circle, Peter, James, and John, up the mountain toward the right. Without warning, Jesus "was transfigured before them" (Mark 9:2). Luke adds the detail that "His face was altered" (Luke 9:29). The radiance emanating from Christ surpassed everything found on earth, illuminating His entire being and even garments: "His clothes became shining, exceedingly white" (Mark 9:3).

The focal point of the icon, in both size and central emphasis, is the transfigured Christ adorned in a radiant white robe. The white robe stands in sharp contrast to the typical inner red and outer blue garment. Where the Lord is shown three places (in the seventeenth-century Dionysios Monastery icon, shown earlier, and in the sixteenth-century Spaso-Preobrazhensky Monastery icon), only Christ's garment at the center of the icon is white.

To the astonishment of the disciples, Elijah and Moses suddenly appear and are engaged in conversation with Jesus (Mark 9:2–4). The Greek words next to each figure's head display their respective names: Prophet Elijah, Prophet Moses. Even with this very basic summary of events, it is reasonable to assume that the disciples were overcome by what they experienced, which explains why these three members of Christ's inner circle are depicted in various stages of distress in the icon.

Elijah and Moses

Both Elijah and Moses had experienced their own mountaintop theophanies in the past. God revealed Himself to Elijah on Mount Horeb in a "still small voice" (1 Kings 19:12) and to Moses on Mount Sinai in the burning bush (Exod. 3:14). Here on this mountaintop, the disciples also experienced the reality of Christ's divinity.

Both Elijah and Moses are depicted in animated stances as if they are engrossed in a lively and serious conversation with Jesus and with each other (Luke 9:30–31). Moses, representing the Law, is depicted holding a tablet, while Elijah, representing the prophets, is portrayed in a manner consistent with the description of him as "a hairy man

Figure 9.16. Mosaic Icon of the Transfiguration, from Saint Paul Greek Orthodox Church in Irvine, California

wearing a leather belt" (2 Kings 1:8), alluding to clothing of coarse animal hair worn by the prophets (Zech. 13:4, Matt. 3:4).

What more do we know about these two significant figures from the Old Testament? While the Old Testament mentions the death of

Figure 9.17. Sixteenth-century Icon of the Transfiguration of Christ, from the Benaki Museum in Athens, Greece

Moses (Deut. 34:5), Elijah's departure from this world is depicted quite differently—as an ascent via a chariot of fire (2 Kings 2:11). This distinction between their exits signifies that Jesus is "Lord of both the dead and the living" (Rom. 14:9). Another difference is that Moses was married, but Elijah remained unmarried and celibate. In this respect, both figures represent the diverse categories of the Israelite people, all anticipating the arrival of their long-awaited Messiah. By their presence, Elijah and Moses affirm to Peter, James, and John

that Jesus is truly the fulfillment of ancient prophecies, confirming His identity as the long-awaited Savior.

Peter, James, and John

Peter, at the bottom left of the icon, seems to have recovered first from the initial surprise and appears poised to speak out. Yet he is

Figure 9.18. Sixteenth-century Icon of the Transfiguration, from the Hermitage Museum in Russia

apparently still befuddled, because in suggesting that the disciples make three tabernacles (Mark 9:5), Peter has improperly assigned Elijah and Moses the same level of honor as the Son of God. Clearly, as Saint Mark recounts, Peter "did not know what to say, for they were greatly afraid" (9:6). Further confounding them, they became enveloped by a dense cloud through which the disciples heard the Father say, "This is My beloved Son. Hear him!" (9:7).

James and John appear overwhelmed, to the extent that they might be physically unwell. An interesting detail in many versions of the Transfiguration icon is that James is shown as having lost a sandal, a detail not mentioned in the Gospel accounts. However, this seemingly minor detail holds deeper symbolism, drawing from a broader biblical context. The sandal recalls the Lord's instruction to Moses: "Take your sandals off your feet, for the place where you stand is holy ground" (Exod. 3:5). Similarly, the displaced sandal signifies that the place of the Transfiguration on Mount Tabor is also regarded as "holy ground."

What Did They Perceive?

Peter later wrote in his second letter that he and the two other disciples heard the voice of the Father "when we were with Him [Jesus] on the holy mountain" (2 Pet. 1:16–18). Both Moses and Elijah, in their own time, had experienced God's presence in the form of light and fire. Elijah experienced God's presence as fire on Mount Carmel (1 Kings 18:38). Moses could not see God's face on Mount Sinai, but the divine radiance he experienced was so strong that his own face shone (Exod. 34:29–35). One might wonder, then, what exactly these three disciples perceived. Did they actually see a visible light when Jesus's "face shone like the sun" (Matt. 17:2)?

Gregory Palamas, a fourteenth-century archbishop of Thessaloníki, taught that the light the Apostles perceived on Mount Tabor was the **uncreated glory** of God (Luke 9:32). Their perception of His divine glory was an experience beyond physical sight. This is the "true light" of which the Evangelist John spoke (John 1:9), and it is the

By the hand of Fr. Tom Tsagalakis

Figure 9.19. The Transfiguration (The Metamorphosis)

essence of Christ's Incarnation. The light of Christ's uncreated glory is the same light that Moses and Elijah experienced, and the same light perceived by Peter, James, and John at Christ's Transfiguration.[8]

Iconographically, the uncreated glory of Jesus Christ is always rendered by what is typically an oblong shape behind Christ. This element

8. See the discussion in *Gregory Palamas: The Triads*, ed. John Meyendorff (Mahwah, NJ: Paulist Press, 1983), 31–40.

is called the **mandorla**, from the Latin word for "almond."[9] The background of the mandorla is a dark color, which accentuates the bright white rays that extend from the center. The rays represent Christ's "uncreated glory" reaching out toward the disciples and into all creation.

The Orthodox Christian understanding of the Transfiguration of Jesus Christ is that it was neither merely a past event nor a foreshadowing of a future reality. It also was not something that happened only to Jesus while the three disciples observed passively. In His Transfiguration, Jesus Christ revealed His divine radiance to His disciples for their benefit, and they were altered by it. Therefore, the real significance of Christ's Transfiguration is not limited to these three disciples, or even to Elijah and Moses, but extends to all humanity. The Icon of the Transfiguration invites viewers to contemplate how the incarnate God reveals His glory in the world, acknowledging along with Moses and Elijah that Jesus is the true Messiah, the Anointed One of God.

After this profound experience Jesus leads His disciples down the mountain (as shown on the right side of the first two examples of this icon). The three disciples are shown as intently looking at Jesus as He commands them to keep what they have just seen a secret until "the Son of Man is risen from the dead" (Matt. 17:9). Even after this dramatic event, they still did not fully understand and were left "questioning what the rising from the dead meant" (Mark 9:10).

As we conclude our study of the Icon of the Transfiguration, I would like to share a contemporary devotional painting of the Transfiguration of Jesus Christ created by a professional Orthodox Christian artist, my friend Angelica Sotiriou-Rausch. The awe-inspiring piece is a massive ten-foot-high mural that constitutes religious art rather than an Orthodox icon. Angelica has incorporated highly iridescent pigment into the painting, making it a truly captivating piece to experience in person. Initially, when Angelica showed me the painting, it did not resemble the Transfiguration to me—until she described her artistic process. Her original intention was to paint

9. The mandorla appears again in the Icon of the Resurrection and the Icon of Christ's Ascension.

Angelica Sotiriou-Rausch

Figure 19.20. Contemplative painting of the Transfiguration

something closely resembling the traditional Orthodox Icon of the Transfiguration. However, during the process of painting, she came to the realization that she was not spiritually prepared to envision herself present with the three disciples witnessing Christ's Transfiguration. Instead, she reflected on how the scene might be perceived from the perspective of someone longing to be present with Jesus, Peter, James, and John, but viewing from a distance, from the back side of the mountain. The result is a painting that evokes deep yearning for communion in the uncreated glory of Jesus Christ—a longing that nurtures and sustains the Christian life.

10

Jerusalem before the Cross

The Raising of Lazarus

The biblical account of Christ's raising of Lazarus from death (John 11:1–48) weaves together a rich tapestry of events, truths, religious and political intrigues, signs and wonders, friends, foes, disciples of Jesus Christ, and even the shortest verse of the Bible.[1] The icon vividly captures the multifaceted nature of the event, setting the stage of Lazarus's illness and the conspiracy by Jewish leaders to kill Jesus after Lazarus is raised. The icon also conveys the diverse perspectives of the people present, such as Mary and Martha, the disciples of Christ, the spectators, and even the spies of the Pharisees.

The biblical narrative unfolds when Jesus and His disciples are informed that their friend Lazarus is gravely ill. Despite Jesus's evident love for Lazarus and his sisters, "He stayed two more days in the place where He was" (John 11:1–6), a decision that would have piqued the curiosity of His disciples.

Only after waiting for four days did Jesus inform His disciples that they would return to Judea, to the town of Bethany where the

1. "Jesus wept" (John 11:35).

Figure 10.1. Twentieth-century Icon of the Raising of Lazarus

siblings lived. Jesus explained to them why He delayed: "Lazarus is dead. And I am glad for your sakes that I was not there, that you may believe. Nevertheless, let us go to him" (John 11:14–15). Jesus

was fully aware of Lazarus's death and that He would raise Lazarus from the dead. Jesus also knew that this would be one of the most important "signs and wonders" for His disciples to witness, because He knew that His arrest and Crucifixion were soon to follow. What awaited them in Bethany would address the disciples' earlier confusion when they pondered what Jesus meant by "rising from the dead" (Mark 9:10) after His Transfiguration.

Mary and Martha

The icon narrative begins at the far left when Jesus and His company arrive in Bethany after Lazarus has been in the tomb for four days. When the two sisters of Lazarus, Mary and Martha, learn that Jesus is on His way to Bethany, Martha runs out to meet Him and expresses her deep faith mixed with great sorrow: "Lord, if You had been here, my brother would not have died. But even now I know that whatever You ask of God, God will give You" (John 11:21–22).

Martha appears near Jesus in the icon as one visibly grief-stricken. He tells her, "I am the resurrection and the life. He who believes in Me, though he may die, he shall live. And whoever lives and believes in Me shall never die. Do you believe this?" (John 11:25–26). Martha responds to Jesus and affirms, "Yes, Lord, I believe that You are the Christ, the Son of God, who is to come into the world" (11:27).

Martha then goes back to their home to retrieve Mary, who has been inside with the other mourners. When Mary sees Jesus, she tells Him the same thing as her sister did earlier: "Lord, if You had been here, my brother would not have died" (John 11:32). Mary is shown with her sister Martha, at the feet of Jesus. Mary is touching His feet and wrapping them with a cloth. This is because of what is said about her at the beginning of the chapter, where Mary of Bethany is identified as "that Mary who anointed the Lord with fragrant oil and wiped His feet with her hair, whose brother Lazarus was" (11:2).

Figure 10.2. Mosaic Icon of Christ Raising Lazarus from the Dead, from Saint Paul Greek Orthodox Church in Irvine, California

Jesus Wept

Jesus reacts to the deep sorrow of the two sisters at the death of their brother with compassion and grief: "He groaned in the spirit and was troubled" (John 11:33). He then takes immediate action: "And He said, 'Where have you laid him?' They said to Him, 'Lord, come and see'" (11:33–34). It was at this point that John recounts that "Jesus wept" (11:35). That simple statement holds profound significance as a poignant example of Jesus's compassion. Despite knowing about Lazarus's death before setting out for Bethany, and knowing that He was going to raise Lazarus, as He informed His disciples (11:14–15), Jesus is deeply moved by the mourning of His friends.

What we read in the written Gospel account and see in the painted or mosaic icon is that the Creator of the universe, the Lord and Savior of the world, was brought to tears by the sorrow of His friends—even though He knew that their grief would be short-lived. Christ's earlier words to Martha affirm His divine intention to offer life to His creation: "I am the resurrection and the life. He who believes in Me, though he may die, he shall live. And whoever lives and believes in Me shall never die" (John 11:25–26).

The Main Event

And now, as the central focus of the icon, Jesus is at the tomb, with His hand raised, ordering that the stone be taken away (John 11:38–40). Martha is shown elevated on her knees, with her hands covered in respectful supplication. The always practical Martha now voices her concern to Jesus that "by this time there is a stench, for he has been dead four days" (11:39). Jesus allays her worries by reminding her that she will see the glory of God (11:40). Then the stone is

Figure 10.3. Icon of the Raising of Lazarus from St. George Orthodox Cathedral in Toledo, Ohio

removed from the tomb, as depicted in the icon, by a young man on the right. It turns out that Martha was entirely correct! The grave stinks with death, as is evidenced by the man to the left of the grave covering his nose with his cloak to minimize the stench.

With Lazarus still in the grave and the tomb now opened, Jesus lifts up His eyes in supplication to His Father: "Father, I thank You that You have heard Me. And I know that You always hear Me, but because of the people who are standing by I said this, that they may believe that You sent Me" (John 11:41–42). Jesus next speaks a clear and direct order to Lazarus, "Lazarus, come forth!" (11:43). And Lazarus does just that! Lazarus walks out of the tomb still wrapped from head to foot in graveclothes (11:44). The icon shows Lazarus very much alive, while another young man is shown responding to Jesus's directive, "Loose him, and let him go" (11:44), by beginning to unwrap the graveclothes around Lazarus.

Not the End of the Story

This is not the end of the story, because the raising of Lazarus from the dead sets into motion another series of cosmic and consequential events. We are told that many of those who were with Mary saw what happened and believed in Jesus. But there were others who were spies of the Pharisees (John 11:45–47), and they immediately reported to the Jewish leaders what they had witnessed. Some observers became believers, while others became betrayers. Both reactions are evident in the icon.

Some of the observers shown at the top center of the icon (in front of the open temple gates in this chapter's first two examples) are shown with full faces. In icons, righteous people are always rendered facing forward with both eyes and at least three-quarters of their face showing. The unbelievers, the hard-hearted and unrepentant sinners, however, are shown either in profile or with only a small portion of their faces showing, as are the Jewish spies in this icon. (We will observe this iconographic attribute a few more times in the way Judas is portrayed as we journey toward Christ's Crucifixion).

The end of this story is really the beginning of the plan to crucify Jesus Christ. After the spies reported what they had seen, the chief priests and Pharisees held a council to decide how to protect themselves from Jesus's popularity: "Then, from that day on, they plotted to put Him to death" (John 11:53).

Forty-Eight in One

Before we move on, notice that this epic historical event, spanning forty-eight dense and important verses, is shown in just one icon panel. The icon captures Jesus's arrival with His company at the beginning of the pericope with Lazarus after he has been brought back to life. Both moments are portrayed simultaneously, showing a visual narrative that intertwines various aspects of the biblical narrative. Mary and Martha can be seen lamenting, "Lord, if you would have been here our brother would not have died," while Lazarus emerges from the tomb alive. Additionally, the icon represents both allies and adversaries. This icon is a perfect example of how icons are meant to convey a broader narrative rather than freezing a singular moment in time. In this representation, the icon powerfully illustrates Christ's authority over death as the God of Life, while also showcasing His limitless mercy and compassion for His creation. The icon elegantly reveals all of these divine attributes: power, compassion, and especially mercy.

Why Is Lazarus Still Wrapped Up?

Depicting Lazarus still wrapped in his graveclothes as he exits the tomb may initially appear dramatic and surprising. After all, this is what is written in Saint John's Gospel account. However, the Orthodox icon presents the detail not only to capture the joy of the moment but to convey the broader reality that Lazarus will eventually require graveclothes again. He will die again—but not for a while!

This remarkable story continues beyond the pivotal moment of Lazarus's rising. The ancient tradition traces Lazarus and his sisters to Greece after Christ's Resurrection, and there Lazarus was ordained

Figure 10.4. Mosaic Icon of Saint Lazarus of Bethany, from the Church of Saint Sava in Belgrade, Serbia

by Paul and Barnabas as the first bishop of Kition in Cyprus. Lazarus served there in ministry for over thirty years after his first death.[2]

2. David Farmer, *The Oxford Dictionary of Saints*, 5th rev. ed. (Oxford: Oxford University Press, 2011), 266.

Palm Sunday: The Triumphal Entry into Jerusalem

The Triumphal Entry of Christ into Jerusalem is narrated in all four Gospels (Matt. 21:1–11; Mark 11:1–11; Luke 19:28–44; John

Figure 10.5. Sixteenth-century Icon of the Palm Bearing by Theophan the Cretan, from Greece

By the hand of Tom Clark

Figure 10.6. Palm Sunday

12:12–19) and is typically commemorated as Palm Sunday. Figures 10.5 and 10.6 are two different icons of Christ's entrance into Jerusalem, created over five hundred years apart. The first (fig. 10.5) is a sixteenth-century Greek icon by the hand of Theophan the Cretan, with the title in Greek (*Hē Baiophoros*/'Η Βαϊοφόρος), which means "The Palm Bearing." Icons are never signed, so it is unusual when we know the name of an ancient iconographer. In this case, Theophan the Cretan was well known for work in two ancient monasteries that are still in existence and active today in Greece: the Monastery of Saint Nicholas Anapausas in Meteora and the Monastery of Stavronikita on Mount Athos. The second icon (fig. 10.6) is by the hand of contemporary American iconographer Tom Clark.

Just as in the written Gospel, the Icon of the Triumphal Entry of Christ directs our attention to the central theme: Jesus enters Jerusalem riding on a humble donkey. His body is depicted facing forward, with His head turned away from His destination and fully facing the viewer. Jesus's right hand offers a blessing in His name to the crowd, while the scroll in His left hand serves as a symbol of His message. The irony of this entire scene is not lost on the reader of the Bible or the viewer of the icon. Jesus enters Jerusalem not as a traditional conquering hero riding a chariot pulled by a team of powerful stallions and laden with the spoils of victory. Instead, He rides upon a lowly colt, the foal of a donkey (Matt. 21:5)—a simple working animal. There are no armed guards accompanying Jesus, only His disciples, who have yet to fully comprehend the significance of the unfolding events. With profound humility, Jesus makes His way into Jerusalem toward His inevitable Crucifixion.

This unusual entrance would not have been lost on the faithful Jews who would have recognized the prophecy from Zechariah:

> Rejoice greatly, O daughter of Zion!
> Shout, O daughter of Jerusalem!
> Behold, your King is coming to you;
> He is just and having salvation,

Lowly and riding on a donkey,
A colt, the foal of a donkey. (Zech. 9:9)

Furthermore, the Jews would have been familiar with the rest of
the passage, which emphasizes that this King arrives in peace, without
a chariot, a horse, or instruments of war:

I will cut off the chariot from Ephraim
And the horse from Jerusalem;
The battle bow shall be cut off.
He shall speak peace to the nations;
His dominion shall be "from sea to sea,
And from the River to the ends of the earth." (Zech. 9:10)

Figure 10.7. The crowd in the sixteenth-century Icon of the Palm Bearing
by Theophan the Cretan (see fig. 10.5)

Because the "very great multitude" (Matt. 21:8) of Jews present were aware of the prophecy concerning the coming of the Messiah, they spontaneously erupted in their shouts: "Hosanna to the Son of David! Blessed is He who comes in the name of the LORD! Hosanna in the highest!" from Psalm 118:26 (see Matt. 21:9; Mark 11:9; John 12:13).

Nevertheless, it is unfortunate that many from this same crowd would not continue to be supportive just a few days later, when Pontius Pilate would ask them to choose between freeing the murderer Barabbas or Jesus (Matt. 27:21). As seen previously in the Icon of the Raising of Lazarus, iconographers depict the faithful in at least three-quarter face and looking forward. In contrast, unrepentant sinners and those whose hearts have been hardened against God (John 12:37, 40)—such as those who would later shout "Crucify Him!" (Mark 15:13–14)— are portrayed in profile or with a minimal part of their face showing.

The Donkey

Zechariah the prophet foretold that Israel's King is coming, "lowly and riding on a donkey / A colt, the foal of a donkey" (Zech. 9:9). Matthew's account references this specific prophecy but mentions two donkeys—a mother and her colt (Matt. 21:6–7). The narratives in Luke and Mark, however, indicate that the Lord asked for one colt "on which no one has ever sat" (Luke 19:30, similarly Mark 11:2). Therefore, Matthew's account in which there may have been two donkeys seems consistent, since the young colt would be more inclined to follow its mother.

In terms of symbolism, the donkey is portrayed as graceful, bowing its head with reverence. This reflects a theme observed in other icons (such as the Icon of the Baptism of Christ) in which animals and nature are depicted as praising the Lord (Ps. 148:7–12). Additionally, the hooves of the colt carrying Christ do not touch the ground. They appear to be floating without any effort.

Jerusalem and the Tree

The procession moves from left to right with the imposing destination city of Jerusalem depicted at far right. The buildings, while large,

Figure 10.8. Fresco of the Triumphal Entry into Jerusalem, from Nativity of the Theo-tokos Church in Bitola, Republic of North Macedonia

are not rendered according to natural perspective. They are shown both frontally and from above, giving a sense of an otherworldly structure. Moreover, the absence of a physical light source results in a lack of shadows and thus no perception of depth. Notice also the inverse perspective apparent in the depiction of the buildings of Jerusalem.

A prominent feature in the icon is the large tree at the center. The tree is characterized by an excited and exaggerated style, and it serves as a focal point because members of the crowd "cut down branches from the trees" (Matt. 21:8; Mark 11:8). The tree holds added symbolic significance as it represents the impending moment when Jesus will ascend the "tree of the Cross"[3] to be crucified for the salvation of all. Apart from this tree, the icon does not depict any other notable features in the landscape. Through the tree, the icon introduces the viewer to a cosmic depiction of future salvific events as prophecies of the Messiah's triumphal arrival in Jerusalem are being fulfilled (Zech. 9:9).

3. The Cross is referred to as a "tree" in several places in the New Testament, such as Acts 5:30; 10:39; 13:29; Gal. 3:13; 1 Pet. 2:24.

The Children

In figure 10.5, figures on the ground who appear to be miniature adults are in fact children who have cut down palm branches. In many icons, as in the sixteenth-century example, children are portrayed in the large tree cutting palm branches. The icon also depicts palm branches and clothes strewn along the path on the ground. Notably, one child is consistently depicted directly in front of the approaching procession, laying down a garment to show honor to Jesus as He enters the gates of the city.

While the children's presence at the moment of Christ's entry into Jerusalem is not explicitly mentioned in the Bible, their involvement is apparent as the chief priests later become "indignant" at the children crying out: "Hosanna to the Son of David!" (Matt. 21:15). Jesus's response to the chief priests and scribes reminds them of the prophecy that even infants will recognize and worship the Messiah: "Have you never read, 'Out of the mouth of babes and nursing infants You have perfected praise'?" (21:16).

The Mystical Supper

The Last Supper narrative begins with Jesus sending two of His disciples to locate a man carrying a pitcher of water, who will lead them to a house where they can eat the Passover meal. This would have been an unusual sight in their day since it was mainly the women who carried water. Jesus's disciples easily find this man, inquire about the guest room, and begin making preparations for the Passover (Mark 14:12–16).

The icon narrative begins in the evening of this day, with Jesus and His twelve who "sat and ate" (Mark 14:17–18). The red cloth drape shown in the icon by the hand of Tom Clark immediately signals that the biblical event takes place indoors in a spacious upper room (14:15).

The table, usually round or semicircular, is depicted with its widest part nearest the viewer, thus serving as an invitation to the observer to join the feast. A few items are visible on the table, rendered

Figure 10.9. The Mystical Supper

without shadows since there is no light source in an icon.[4] Notably here, only Jesus is shown with a halo, since the Holy Spirit has not

4. The implied source of light in icons is Jesus Christ (John 8:12).

yet descended on His disciples. The twelve, except for two, are shown as being engaged in discussion during the meal.

At one point during the meal, Jesus reveals to His disciples that one of them will soon betray Him. A few of His disciples question Him with "Is it I?" (Mark 14:19). But Jesus is specific about the identity of the betrayer, saying, "It is one of the twelve, who dips with me in the dish" (14:20). One disciple is depicted as reaching to dip with Jesus. It is Judas, who is shown in profile, in the typical way that an unrepentant sinner appears in icons, as he willingly betrayed Jesus to the Jews for thirty pieces of silver (Matt. 26:15). Another disciple not engaged with conversation is shown leaning on Jesus during this supper. Although he is not mentioned in any of the accounts in the Synoptic Gospels, John later reveals in his Gospel that it was he who leaned on Jesus during the meal: "Now there was leaning on Jesus's bosom one of His disciples, whom Jesus loved" (John 13:23).[5]

Orthodox Christians understand the Last Supper to be the institution of the Holy Eucharist, bearing significance beyond a mere remembrance of an important past event.[6] The depiction of this event in the icon is labeled "The Mystical Supper" (Greek: *Mystikos Deipnos*). "Mystical" reflects what is indicated by the words and actions of Jesus, that this is not merely an earthly meal: "And He took bread, gave thanks and broke it, and gave it to them, saying, 'This is My body which is given for you; do this in remembrance of Me.' Likewise He also took the cup after supper, saying, 'This cup is the new covenant in My blood, which is shed for you'" (Luke 22:19–20). This meal, as blessed and instructed by Jesus, is a foretaste of the meal to which He has invited His followers in His Kingdom: "And I bestow upon you a kingdom, just as My Father bestowed one upon Me, that you may eat and drink at My table in My kingdom" (22:29).

5. There are six references to "the disciple whom Jesus loved" (John 20:2) in John's Gospel, but no other mentions throughout the New Testament. The ancient Christian tradition understands the beloved disciple to be the Evangelist John.

6. See Eve Tibbs, "The Eucharist Is Life," in *Re-Introducing Christianity: An Eastern Apologia for a Western Audience*, ed. Amir Azarvan (Eugene, OR: Wipf & Stock, 2016), 147–54.

Figure 10.10. Mosaic Icon of the Mystical Supper, from the altar of Saint Paul Greek Orthodox Church in Irvine, California

The Washing of Feet

In the Jewish culture, a disciple would never be asked to do such a lowly and insulting task as wash his rabbi's feet. In fact, even Jewish slaves would not be asked to wash their masters' feet, a task reserved for Gentile slaves.[7] In John's account, following the Last Supper (John 13:2–17), an astonishing act occurs. Instead of asking His disciples to serve Him, Jesus humbles Himself to wash their feet. This striking example of humility and servant leadership

7. Craig A. Evans, ed., *The Bible Knowledge Background Commentary: John's Gospel, Hebrews–Revelation* (Colorado Springs: Victor Books, 2005), 121.

Figure 10.11. Sixteenth-century Icon of Christ Washing the Disciples' Feet, from the Pskov Museum in Russia

comes amid two mentions of Judas's betrayal. John writes that Judas had already decided to betray Jesus (13:2). Jesus would later refer to Judas's betrayal by declaring to His disciples, "You are not all clean" (13:11).

The icon depiction begins where the New Testament narrative begins, with Jesus Christ and two opposing characters: Judas and Peter. Jesus has taken a towel and wrapped it around Himself, a detail that the icon renders literally from the biblical text. When Jesus "laid aside His garments, took a towel and girded Himself" (John 13:4), He adopted the posture of a slave.[8] This entire event highlights a spiritual hierarchy that contrasts entirely with earthly power dynamics. Jesus's actions demonstrate that true leadership is not about self-importance or status. Jesus encourages His disciples to emulate His example—"do as I have done to you" (13:15)—by serving one another humbly, as in the posture of a slave.

Peter is the first to have his feet washed by Him, and Judas is last. The other ten disciples are depicted in various positions, awaiting their turn. They are of lesser significance to this story, as only Peter and Judas are directly mentioned in the biblical passage, for specific reasons.

A closer look at the entire pericope in John's Gospel and in the icon reveals a different set of opposites, perhaps an even more profound contrast than the humility of the Master washing the feet of His disciples. The two opposites are love, personified by Peter's actions, and betrayal, personified by Judas's actions. John sets the scene with both commitments at the outset of the narrative of the foot washing: "Jesus . . . having loved His own who were in the world, He loved them to the end" (13:1), followed immediately by "supper being ended, the devil having already put it into the heart of Judas Iscariot, Simon's son, to betray Him" (13:2).

In both versions of this icon, Peter is positioned at the far left of the icon next to Jesus. Peter's expression in the icon is one of concern, and perhaps even distress, reflecting both his initial resistance and his eventual acceptance. According to the Gospel of Saint John, Peter strongly opposes the notion of Jesus washing his feet—"You shall never wash my feet!" (John 13:8)—evident through his unsettled posture and obvious discomfort. Jesus does not proceed against Peter's

8. Evans, *Bible Knowledge Background Commentary*, 121.

Public Domain / Wikimedia Commons

Figure 10.12. Thirteenth-century mosaic Icon of Christ Washing the Disciples' Feet from Saint Mark's Basilica in Italy

will without offering Peter a choice: "If I do not wash you, you have no part with Me." Peter accepts the Lord's expression of love and ultimately proclaims: "Lord, not my feet only, but also my hands and my head!" (13:9). The icon gives evidence of Peter's acceptance by showing him pointing to His head.

The way Peter and Judas are represented in the icon makes the contrast between Peter's response to Christ's love and Judas's rejection and betrayal even more obvious and emphatic.[9] Eleven of the disciples are shown in full face. Again, in traditional iconography, a righteous person is typically depicted with at least three-quarters of a full face, with both eyes visible. In the linear mosaic icon (fig. 10.12), Judas is portrayed last, and in profile with only one eye showing, while in the icon with the circular arrangement (fig. 10.11), Judas is positioned at the bottom in profile. Both versions are conveying that Judas is unlike the others; he is rendered as an unrepentant sinner. Judas was offered Christ's love but has rejected it; he has instead chosen betrayal.

9. Jan van der Watt, "The Meaning of Jesus Washing the Feet of His Disciples (John 13)," *Neotestamentica* 51, no. 1 (2017): 28.

<div align="center">

11

The Cross, the Tomb,
the Resurrection

</div>

First Things First: What Is the Problem?

Genesis 3 describes a cataclysmic event caused by human action that resulted in a breach with the Creator. The various interpretations of "the Fall"[1] constitute some of the more significant theological differences between the Christian East and the Christian West. Therefore, it is helpful to step aside from the icons for a moment to establish a context for what will be seen and described in the Orthodox icons of the Crucifixion and the Resurrection that follow.

In much of the Roman Catholic and Protestant West, the problem of humanity is often understood through the lens of Augustine of Hippo, a fifth-century bishop. Augustine imagined that Adam's disobedience against God incurred something like a debt with the penalty inherited biologically by Adam's descendants. Thus, Augustine

1. The Orthodox world typically refers to the Gen. 3 event with terms like "ancestral sin" or "primal curse."

argued that every human is also guilty of Adam's "original sin."[2] According to this perspective, the solution to the human problem lies in the innocent Jesus taking on the punishment for all of humanity, thereby settling the debt humankind owed to the Father, through His sacrificial death on the Cross.[3]

Eastern Orthodox Christianity certainly acknowledges the disruptive impact of Adam and Eve's actions on the entire created world, and it recognizes Jesus Christ as the only solution. However, the Eastern Christian stance differs from Augustine's interpretation. According to the Orthodox belief, our primal ancestors were given an entire garden to oversee, to use, and in which to be fruitful and multiply. Rather than thanking the Creator for all they had been given, Adam and Eve coveted—and ultimately took—the one thing God did not give them. Their disobedience is viewed not merely as a transgression but as a turn toward idolatry. Whatever else that fruit represents, it had no life in itself. It was an inanimate created thing—an idol. Adam voluntarily turned away from the life-giving God and toward the dead idol he desired, thus ushering in death.[4]

In the Orthodox understanding, only Adam bears the guilt for his rejection of God; yet through his failure, all creation suffers with something like an inherited illness.[5] We are being held captive against our will by our common enemy, death, because of which sin and evil prevail. But as Jesus told Martha, the sister of Lazarus and Mary, He intended to remedy the problem of death: "I am the

2. This idea was based on Augustine's distinctive interpretation of Rom. 5:12–23. See David Bentley Hart, "*Traditio Deformis*," *First Things* (May 2015), https://www.firstthings.com/article/2015/05/traditio-deformis.

3. See Augustine of Hippo, De Peccatorum Meritis et Remissione (On Merit and the Forgiveness of Sins, and the Baptism of Infants), book 1, New Advent, https://www.newadvent.org/fathers/15011.htm.

4. Alexander Schmemann, *For the Life of the World: Sacraments and Orthodoxy* (Crestwood, NY: St. Vladimir's Seminary Press, 1998), 16–18.

5. For a discussion on the Orthodox Christian view of the Fall and what Jesus has done to save us, see chap. 6 in Eve Tibbs, *A Basic Guide to Eastern Orthodox Theology: Introducing Beliefs and Practices* (Grand Rapids: Baker Academic, 2021), 99–124.

resurrection and the life. He who believes in Me, though he may die, he shall live" (John 11:25). Additionally, as Jesus clearly intends to convey in His telling of the parable of the prodigal son, the merciful Father requires no payment to forgive but only repentance (Luke 15:11–32).

Jesus Restores, Heals, Conquers

The Orthodox Christian solution to the cosmic problem of humanity is that the Son of God emptied Himself of His exalted status in heaven and became one of us (Phil. 2:5–11). He did this to defeat humankind's enemies, heal its inherited fatal illness, and restore the ruptured relationship between humanity and God. As fully God and fully human, Christ's Incarnation restores the severed human communion with God—in Himself. In His Baptism, the human condition is healed, and through His Crucifixion and Resurrection, He conquers the "last enemy": death.[6]

And so, as we approach the Icon of the Crucifixion, it is helpful to keep in mind that Orthodox eyes do not see a defeated and helpless victim on the Cross, but rather the King of Glory, Who ascended the Cross voluntarily. The Cross cannot hold the God Who created the tree from which the Cross itself was formed. Death cannot hold the Creator of life itself. In His humility and love for His creation, Jesus Christ reigns from the Cross as King and God.

The Crucifixion

As mentioned in chapter 1, a seventh-century monk, Anastasios of Sinai, became frustrated that those who wrongly taught that Jesus had only one nature ("monophysites") were twisting the words of Scripture to serve their own agenda. Anastasios determined that a better way to express correct theological teaching would be to use

6. "The last enemy that will be destroyed is death" (1 Cor. 15:26).

Figure 11.1. Sixteenth-century Russian Icon of the Crucifixion, from the National Museum in Stockholm, Sweden

icons, since they could not be manipulated. In defense of Christ's two natures, Anastasios presented just one icon—the Icon of the Crucifixion of Jesus Christ. Defending his use of this one icon, Anastasios offered his opinion that material images are "stronger, more faithful, and mightier by far than the verbal words and

biblical quotes."[7] As we shall see, this icon shows that Jesus indeed suffered on the Cross as any human would. Yet He is portrayed in the icon with peaceful resignation and with supreme humility as the King of Glory—the incarnate God Who conquers death and renews creation.

I am presenting here several very different icons of the Crucifixion of Jesus Christ. First, there is an early sixteenth-century Russian painted icon, followed by a twenty-first-century glass mosaic mural. Then there are two painted panel icons from two contemporary American iconographers. Even though the styles and mediums are very different, the subject and its presentation are remarkably similar for having been created across the span of many centuries and countries.

As all four Gospels tell us, Jesus was hung on a Cross on the wood of a tree: "The God of our fathers raised up Jesus whom you murdered by hanging on a tree" (Acts 5:30). The Crucifixion takes place at Golgotha, identified in Scripture as "Place of a Skull" (Matt. 27:33; Mark 15:22; John 19:17). The icon shows the literal connection to the name, with the skull buried in the ground of the mountain. Golgotha was traditionally considered to be a hilly location outside of Jerusalem. The wall in the background of the icon gives evidence of the event taking place just outside the city. The Cross itself is simple and is shown with a footrest.

There is a plaque over Christ's head, which, according to John, reads, "Jesus of Nazareth, the King of the Jews" in Hebrew, Latin, and Greek (John 19:19). In the mosaic icon shown here, the Greek is abbreviated as INBI, using the first Greek letters of the key words in that phrase (Ἰησοῦς ὁ Ναζωραῖος ὁ Βασιλεὺς τῶν Ἰουδαίων). The older sixteenth-century Russian icon reads "King of peace" in **Church Slavonic**, and similarly, the plaque in the contemporary Cassis icon below reads "The King of Glory" in Greek.

7. Anastasios of Sinai, *Hodegos* ("Guide" or *Viae Dux*), chap. 2, referenced in Anna Kartsonis, *Anastasis: The Making of an Image* (Princeton: Princeton University Press, 1994), 40–67.

Figure 11.2. Mosaic Icon of the Crucifixion, from Saint Paul
Greek Orthodox Church in Irvine, California

We witness, both in print and in image, the sorrow of Jesus's mother, Mary (John 19:25–27). Her only child has been tortured and is being crucified as the only truly Innocent among criminals. Yet this mother also knows that her son is God's Son—the only begotten of the Father (3:16). This fact does not eliminate Mary's grief as it does not eliminate Christ's physical pain. Both are real human reactions to this horrific incident.

Even as the human suffering is real, the Orthodox icon will not let us forget Who is actually on the Cross and why He is there. Jesus is not only the King of the Jews and Messiah; He is the Creator and Ruler over all creation. As true God, Jesus could not be held by the Cross if He had not ascended it of His own will. The Orthodox icon does not shy away from the cruelty of this death, but it neither emphasizes nor exaggerates the gruesome physical suffering. The icon mainly puts the entire scene into its greater salvific perspective: the One on the Cross is the God of Life, over Whom death has no power.

Not Forsaken by God

This icon also encompasses the prophecies about what the Anointed One[8] will suffer. Jesus was forsaken by His chosen people, but never by His Father. Yes, "Jesus cried out with a loud voice, saying, 'Eloi, Eloi, lama sabachthani?' which is translated, 'My God, my God, why have You forsaken Me?'" (Mark 15:34; see also Matt. 27:46). This is a direct quotation from Psalm 22:1. Jesus is truly suffering in the flesh, but His words are not a complaint of desolation directed toward His Father. The Lord is connecting His suffering with the Psalm, to proclaim that the Jews are crucifying their own Messiah—the One about Whom the psalmist and prophets foretold.

The Gospel writers tell of Jesus's garments being divided: "They crucified him, and divided his clothes among them, casting lots to

8. *Mashiach* (Messiah) in Hebrew and *Christos* (Christ) in Greek both mean "Anointed One."

By the hand of Paul Akzoul (https://www.traditionalbyzantineiconography.com)

Figure 11.3. The Crucifixion

decide what each should take" (Mark 15:24 NRSV; see also Matt. 27:35; Luke 23:34; John 19:23–24). Yet the psalmist already foresaw that this would be done to Israel's Messiah: "They divide My garments among them, / And for My clothing they cast lots" (Ps. 22:18). Mark and Matthew wrote that "those who passed by derided him, shaking their heads" (Mark 15:29; Matt. 27:39 NRSV), which again confirms Psalm 22:7 ("All those who see Me ridicule Me; / . . . They

shake the head") and Psalm 22:16 ("They pierced My hands and My feet").

Christ's mother is alone at the foot of the Cross in some versions of this icon. Three of the Gospels refer to other women, and we have an example of this in the icon below (fig. 11.4) by the hand of Diamantis Paul Cassis.[9] The initials shown over her head "MP ΘV" are again a hearkening back to the Hebrew four-letter abbreviation for the divine name (or tetragrammaton). The abbreviation is formed with the first and last letters in Greek of the words "Mother of God," which are MHTHP ΘEOY (*Mētēr Theou*).

John the beloved is always shown on the side opposite Mary, since Jesus conveys them to one another as mother and son: "When Jesus therefore saw His mother, and the disciple whom He loved standing by, He said to His mother, 'Woman, behold your son!' Then He said to the disciple, 'Behold your mother!' And from that hour that disciple took her to his own home" (John 19:26–27).

The same John seals himself as an eyewitness to the Crucifixion with an oath: "He who has seen has testified, and his testimony is true" (John 19:35). The Greek writing above John's head is usually either an abbreviation of his name (ιω) (John is spelled Ἰωάννης in Greek) or a longer description identifying him in Greek as "Saint John, the Theologian."

Sometimes there is also shown the centurion who confessed Christ at the Cross: "So when the centurion, who stood opposite Him, saw that He cried out like this and breathed His last, he said, 'Truly this Man was the Son of God!'" (Mark 15:39). The centurion is shown in the Cassis icon as pointing to Jesus. He now recognizes the truth about the One being crucified and confesses his faith in Him as Son of God.

Absent from the iconographic view of the Crucifixion is any solely physical human torment, such as the "blood and guts" we might see

9. Also mentioned along with Jesus's mother were Mary Magdalene, Mary the mother of James and Joses, and the mother of Zebedee's sons (Matt. 27:55–56). Mark also mentions Salome (Mark 15:40–41).

Figure 11.4. Icon of the Crucifixion

in Renaissance or contemporary religious art or movies. Mel Gibson's film *The Passion of the Christ*, for example, is quite horrific in terms of showing the gory details of Jesus's torture and death. In the icon, however, we only see the wounds of the nails in His hands and feet, and sometimes the blood and water streaming from His side after one of the soldiers pierced His side with a spear (John 19:34).

According to Jaroslav Pelikan, this icon illustrates the proper perspective that salvation is not addressed upward from Jesus, Who pays the price to God, but rather downward, from the merciful and loving God Who comes to free us from our enemies.[10]

10. Jaroslav Pelikan, *Imago Dei: The Byzantine Apologia for Icons* (Princeton: Princeton University Press, 2011), 97.

Figure 11.5. Thirteenth-century Icon of the Crucifixion, from Vatopedi Monastery on Mount Athos in Greece

Images of the Resurrection

Within a short period of time, the Gospels recount two empty tombs: the empty tomb of Lazarus of Bethany (see chap. 10) and the empty tomb of Jesus Christ. Scripture tells us how the first tomb was emptied. Lazarus was raised from the dead by the command of Jesus: "Lazarus, come forth!" (John 11:43). Although Jesus Himself foretold *that* He would be "raised on the third day" (Matt. 16:21), the New Testament is entirely silent as to *how* this occurred. The means by which Christ resurrected is simply shielded from human cognition. The Bible is not silent about the risen Christ, however. The New

Testament includes at least twelve separate eyewitness encounters with Jesus after His Resurrection.[11]

Two thematic images of the Resurrection took precedence in the earliest centuries of Christianity and will be described in this section. The first and earliest was a nearly literal representation of the accounts in the Synoptic Gospels of the myrrhbearing women at the empty tomb receiving the news from the angel: "He is not here; for He is risen, as He said" (Matt. 28:6; see also Matt. 28:1–8; Mark 16:1–8; Luke 24:1–12).

The other main image of the Resurrection developed not from the Gospel accounts, but from the whole of Scripture—Old and New Testaments together—offering an all-embracing view of Christ's purposes "in heaven and on earth" (Matt. 28:18). The Resurrection icon brings the **ancestral sin** full circle to its cosmic *telos* and redemption in Christ Jesus. The icon also serves as a helpful exegetical tool, as well as providing insights into the Orthodox Christian emphasis and focus on the Feast of **Pascha** (Easter) as the "Feast of all Feasts."

The Myrrhbearing Women at the Empty Tomb

This icon presents one of two main New Testament events in which angels figure prominently as subjects. The first was the Annunciation by the Archangel Gabriel to Mary, which we encountered in chapter 5. Here, the icon depicts the Holy Myrrhbearers at the empty tomb of Christ. In both cases, the angels have been sent by God to convey an important message for humanity: first that the Son of God is coming (Luke 1:26–38), and now that "He is risen! He is not here" (Mark 16:6).

11. The first post-resurrection encounter with Jesus was with Mary Magdalene at the empty tomb (John 20:11–18). Other encounters with the risen Lord are mentioned in Matt. 28:9–10, 16–20; Luke 24:13–31, 34, 50–51; John 20:19–23, 26–29; John 21:1–14; 1 Cor. 15:6–8.

By the hand of Michael Kapeluck

Figure 11.6. Icon of the Myrrhbearing Women at the Empty Tomb of Christ

It is especially noteworthy that these myrrhbearing women were also instructed by the angel to "go, tell His disciples—and Peter— that He is going before you into Galilee; there you will see Him, as He said to you" (Mark 16:7). The Greek word in the New Testament for one who is "sent" is *apostolos* or Apostle. Because the myrrhbearing women responded quickly and faithfully after being *sent* to announce the Resurrection to the Apostles (16:8), they are all honored in the Orthodox Church with the formal appellation of "Equal to the Apostles."[12]

The Icon of the Myrrhbearing Women at the Empty Tomb offers a close correspondence with the textual presentation in the Gospel accounts of the empty tomb discovered by the women disciples on the morning of the third day.[13] With Jerusalem in the background, the women are shown as bringing spices with them to anoint Jesus's body for burial. They must do this "when the Sabbath was passed"—on Sunday, "the first day of the week" (Mark 16:1–2)—because the Jewish law prevented them from doing so on Friday evening (the start of Sabbath) or on the actual Sabbath day (16:1).

As Mark's Gospel indicates, the angel appears as "a young man clothed in a long white robe sitting on the right side" (Mark 16:5). The angel is shown in this way in the icon: dressed in a long white gown and sitting on the right side of the tomb. The angel is portrayed with wings because the angel is a "messenger" (Greek: *angelos*) of God.[14] The angel is also shown with the flowing curled ribbon around his head—the iconographic attribute that conveys the angel can attend swiftly to God's command and traverse the earth.

12. The specific women mentioned in the Gospels are Mary Magdalene; Mary, the wife of Clopas; Joanna, wife of Chuza, a steward of Herod Antipas; Salome, the mother of the sons of Zebedee; Mary and Martha, the sisters of Lazarus; and Susanna (Matt. 27:55–56; 28:1–10; Mark 15:40–41; Luke 8:3; 24:10; John 19:25). Jesus's mother, Mary, is not described in the Gospels as being present on the Sunday morning when the women came to anoint Christ's body. However, she is often shown in icons, with the idea that as His mother, she simply would not have been absent.

13. This is also the icon and the event that is the focus of the first announcement of the Resurrection on Holy Saturday morning in the Orthodox Church.

14. See chap. 4, "Messengers of God."

The tomb of Christ, however, is not shown literally. It was a cave carved out of a rock, according to Matthew (Matt. 27:60). Here in the icon, the tomb is shown more as a casket and seems to be floating over the rugged opening of a dark chasm. Since the empty tomb is the most important aspect of this event, it receives emphasis in the foreground. The tomb is also rendered with a view from the top, with a flattened and unnatural perspective.

As was already pointed out in the discussion of the Icon of Christ's Nativity in chapter 6, the graveclothes left behind in the empty tomb intentionally closely resemble the iconographic depiction of the swaddling cloth wrapped around the baby Jesus as He lay in the manger. In contrast, the icon that depicts the raising of Lazarus in chapter 10 shows Lazarus still wrapped in his graveclothes—even though He has already been raised from the dead. This conveys the reality that Lazarus will again be wrapped in graveclothes when he ultimately enters eternal life. Here, however, Luke tells us that Peter sees "the linen cloths lying by themselves" (Luke 24:12). Jesus is risen and death has been conquered!

The Resurrection Icon

The twentieth-century marketing adage "A picture is worth a thousand words"[15] is proven no truer than when observing the contrast between the Orthodox Church's Easter imagery and that found in Western forms of Christianity. In fact, a rather significant difference comes to light when the Orthodox Icon of the Resurrection of Christ is compared to Western images of Easter. Consider first the images that might be seen on a typical Easter greeting card, or on the cover of an Easter Sunday church bulletin, or on the video

15. This phrase is commonly attributed as a Chinese proverb. In actuality, the expression "Use a picture. It's worth a thousand words" first appeared in a 1911 newspaper article quoting newspaper editor Arthur Brisbane's discussion of journalism and publicity ("Speakers Give Sound Advice," *Syracuse Post Standard*, March 28, 1911, p. 18). Later, in 1927, an advertising executive admitted to attributing the saying to a Chinese proverb because he wanted it to be taken more seriously.

Eve Tibbs

Figure 11.7. A typical Western image of Easter

screen at a contemporary Easter service. It may be an image of three crosses, with a highlight of some kind on the center Cross; or it may be an empty tomb with light streaming from it, sometimes with Jesus shown standing nearby. The distinctive Western Christian images of Easter convey clearly that the One who died on the Cross—the singular person Jesus—has risen. New Testament scholar John Dominic Crossan refers to this as the "individual version," which he traces to its establishment by the second millennium as the "official Easter icon of Western Christianity."[16]

But what about everyone else? The eyewitness account from Matthew in the New Testament conveys that "the graves were opened; and many bodies of the saints who had fallen asleep were raised; and coming out of the graves after His Resurrection, they went into the holy city and appeared to many" (Matt. 27:52–53). Echoing Saint Paul's "For if

16. Prologue to John Dominic Crossan and Sarah Sexton Crossan. *Resurrecting Easter: How the West Lost and the East Kept the Original Easter Vision* (New York: HarperCollins, 2018).

the dead do not rise, then Christ is not risen" (1 Cor. 15:16), the fourth-century bishop Ambrose of Milan insists that Christ's Resurrection was for us, since He did not actually need to rise: "For if He rose not for us, He certainly rose not at all, for He had no need to rise for Himself."[17]

To identify the significant difference in the images of Easter between West and East, John Dominic Crossan and his wife engaged in twenty research trips over the course of fifteen years, traveling to museums, libraries, and Orthodox churches and monasteries in countries around the Mediterranean and elsewhere expressly to photograph Orthodox icons of the Resurrection. Their conclusion is indicated in the subtitle of their photojournalistic book: *How the West Lost and the East Kept the Original Easter Vision.*[18]

Eastern Orthodoxy has maintained the early church's view that Christ's Resurrection was communal and collective, not individual. Lazarus's rising was an individual resurrection, but Christ's Resurrection is communal—a cosmic victory over death itself for the benefit of all. Every ancient and contemporary version of the Orthodox Icon of the Resurrection reflects this understanding by involving quite a few people in addition to Jesus.

Passover from Death to Life

Easter in the Orthodox Church is called Pascha, which means Passover. It was the blood of the Passover lamb that allowed the Jewish people to pass from death to life and escape the tenth plague (Exod. 11), and it is through the blood of Jesus Christ, "the Lamb of God who takes away the sin of the world" (John 1:29), that His people may pass from death to life and share in His Resurrection.[19] Both

17. Ambrose of Milan, "On the Death of Satyrus," New Advent, https://www.newadvent.org/fathers/34032.htm.

18. Crossan and Crossan, prologue to *Resurrecting Easter.*

19. "Most assuredly, I say to you, he who hears My word and believes in Him who sent Me has everlasting life, and shall not come into judgment, but has passed from death into life" (John 5:24).

Figure 11.8. Early sixteenth-century Russian Icon of the Resurrection of Christ, from the Icon Museum of Recklinghausen in Germany

Passovers from death to life are universal, cosmic, and collective. Jesus emptied **Hades** and offered life and renewal to all:

O Death, where is thy sting? O Hades, where is thy victory? Christ is risen and thou are overthrown. Christ is risen and the demons have

fallen. Christ is risen and the Angels rejoice. Christ is risen and there is none dead in the tomb.[20]

The righteous who have been waiting for this day are now witnesses to Christ having broken the bonds of death by His Cross. They rejoice together as He lifts humanity out of its bondage in Hades.

Shown here are four icons of the Resurrection of Christ in very different styles from across the centuries: a fourteenth-century fresco mural from the ancient Chora Monastery in Constantinople,[21] a Russian-style icon from the sixteenth century, one by the hand of a contemporary iconographer from Pennsylvania, and a large mosaic mural from my church in Irvine, California. One will readily notice that the four icons share many similarities, even as they have been created over a range of more than seven hundred years!

This icon is sometimes referred to as "The Harrowing of Hades" or "The Descent into Hades." Yet "The Resurrection" (Greek: *Hē Anastasis*/Ἡ Ἀνάστασις) is more common, and I believe it is also more accurate. What has happened and what is being portrayed is not a descent at all, but an ascent. Fallen humanity is raised from death to life with the Resurrection of Jesus Christ.

In every version of this icon, Jesus Christ stands upright upon the Cross by which He conquered death. Through the iconographic technique of hierarchical perspective, Jesus is the largest figure in the icon and thus the most important. His feet still show the marks of the

20. Saint John Chrysostom, Paschal Homily, Greek Orthodox Archdiocese of America. https://www.goarch.org/-/holy-week-in-the-eastern-orthodox-church. This homily is read and proclaimed annually on Pascha night in Orthodox Resurrection services around the world. Death itself is overthrown (Isa. 25:8); Death has no sting and Hades has no victory (1 Cor. 15:55; Hosea 13:14).

21. In Orthodox practice, Istanbul is commonly referred to as Constantinople, which is the seat of the Ecumenical Patriarch, the spiritual leader of Eastern Orthodox Christians worldwide. In November 2019, the Turkish Council of State, Turkey's highest administrative court, ordered that Chora was to be reconverted to a mosque. In August 2020, its status changed to a mosque. Jayson Casper, "Turkey Turns Another Historic Church into a Mosque," *Christianity Today*, August 21, 2020, https://www.christianitytoday.com/news/2020/august/turkey-chora-church-mosque-kariye-museum-hagia-sophia-istan.html.

Photo: Alex Gorbenko

Figure 11.9. Mosaic Icon of the Resurrection, from Saint Paul Greek Orthodox Church in Irvine, California

Crucifixion. The familiar "O W N" is shown in His cruciform halo, indicating that He is the same "I AM" who spoke to Moses from within the burning bush (Exod. 3:14). Jesus stands in front of the almond-shaped mandorla, which is dotted with stars and has rays extending outward, representing the outpouring of God's uncreated glory into creation.

Jesus shines brilliantly, robed in bright white as the Light of the World (John 8:12; 9:5). His face is tender and determined. He pulls two people out from their tombs—Adam and Eve—who represent all of humanity. Both Adam and Eve are shown half-kneeling, reaching for Jesus's hand, but they actually need to do nothing, as Jesus is pulling them out of their tombs by their wrists. In most versions Christ has taken both by the wrists, but in some (as in the sixteenth-century Russian icon, fig. 11.8) Jesus is grasping only Adam's wrist; Eve waits her turn in patient supplication with her hands covered, showing respect as a humble servant. In all versions Adam is gesturing toward Eve with his right hand, as if asking the Lord to attend to her as well.

In the darkness below are broken chains, open locks, keys, and various similar items which show that the bonds of death have been broken. Hades is now in utter chaos (1 Cor. 15:55). The Evil One is sometimes included in this icon, shown in profile and bound beneath Jesus Christ upon the Cross, as in the contemporary icon by the hand of Michael Kapeluck. As soon as Christ entered the realm of death, it was shattered by His life-giving presence.[22]

At his magnificent preaching following the Descent of the Holy Spirit at Pentecost, Saint Peter told his hearers that it was not possible for the Christ to be held by death (Acts 2:24)[23] and reminded them that King David had foreseen the victory of the Messiah: "For You will not abandon my soul to Hades / Nor allow Your Holy One to see corruption" (Ps. 15:10 LXX; similarly, Acts 2:31).[24]

22. "For as Jonah was three days and three nights in the belly of the great fish, so will the Son of Man be three days and three nights in the heart of the earth" (Matt. 12:40).

23. ". . . whom God raised up, having loosed the pains of death, because it was not possible that He should be held by it" (Acts 2:24).

24. This translation is from *The Orthodox Study Bible* (Nashville: Nelson, 2008).

By the hand of Michael Kapeluck

Figure 11.10. Icon of the Resurrection

Two versions of the icon include angels at the top of the icon. They are proudly displaying the Cross: the new banner of Christ's victory and of the Christian Faith. The Kapeluck icon (fig. 11.10) shows the angel on the left holding a Russian-style cross with a footrest. One

Figure 11.11. Fourteenth-century Icon of the Resurrection, from the Monastery of Chora in Constantinople (now Istanbul), Turkey

side of the footrest slants upward to symbolize the faith of the one thief (of two) crucified with Christ who said: "Jesus, remember me when you come into your kingdom" (Luke 23:42).

John the Baptist, who was the Forerunner of Christ in ministry, became the Forerunner in death, preceding Jesus Christ into Hades after he had been beheaded by Herod (Mark 6:14–29). John is typically shown on the left side of the icon directing attention to the Savior with the gesture of an open hand.

In addition to Jesus, Adam and Eve, and John the Forerunner, other righteous biblical figures, kings, and prophets have been waiting for their Redeemer. These are background figures, in a sense, as the whole human race is already being represented by the two main figures of Adam and Eve. The same people are not present in every version of the Resurrection icon, however. Typically, there are prophets on the right side—such as Micah, Isaiah, and Moses—who were given the grace of foreknowledge of the coming of the Messiah. On the left side of the icon is shown King David and King Solomon, ancestors of Christ (Matt. 1:6). David and Solomon are sometimes shown with halos, which identify them as righteous rulers, and they are often looking toward each other as if they are conversing together

about the meaning of this marvelous event. The one person who has waited the longest in Hades—Abel, who was killed by his brother Cain (Gen. 4:8)—is sometimes present at Christ's left, shown as a young man and holding his shepherd's staff, as in the Chora icon.

All the witnesses to Christ's Resurrection are shown facing forward with full face. They are all proclaiming to us, the viewers—the worshipers—that Christ is risen and death has been despoiled. The Orthodox hymn of Pascha is sung joyfully and repeatedly on the night of Pascha and throughout all the services of the Orthodox Church during the forty-day paschal season until the Ascension: "Christ is risen from the dead, by death trampling down upon death, and to those in the tombs He has granted life."[25]

25. Paschal Apolytikion (hymn, also called a **troparion**) of the Orthodox Church, translation copyright of Greek Orthodox Archdiocese of America, https://www.go arch.org/pascha-learn. The Paschal Troparion was originally written in Byzantine Greek in the sixth century. See John Baggley, *Festival Icons for the Christian Year* (Crestwood, NY: St. Vladimir's Seminary Press, 2000), 117, who offers a robust description of the worship of Pascha in chap. 12, "Now Are All Things Filled with Light."

12

After the Resurrection

Forty Days Later: The Ascension of Christ

Luke 24:51–53, Acts 1:9–11

This beautiful, huge, and imposing glass mosaic mural (over twenty feet tall and thirty feet wide) is installed in my home parish of Saint Paul Greek Orthodox Church in Irvine, California. The icon is titled "The Ascension of Christ into Heaven," depicting the biblical event that took place forty days after the Resurrection of Jesus Christ. The Ascension is described both at the end of the Gospel of Saint Luke and at the beginning of the Acts of the Apostles, and it is briefly mentioned by Saint Mark (16:19).

The bodily departure of Jesus Christ from the earth took place on the Mount of Olives near Bethany. The icon shows that all the Apostles are in attendance, as well as Christ's mother, Mary, who stands at the center of the group. Between Jesus and Mary is an imaginary, but intentional, straight line. In showing Jesus directly aligned with Mary, the icon conveys that the Ascension is the summit of Christ's Incarnation. Now the physical human body of Jesus Christ, which He received from Mary, rises to heaven to reign with the Father and the Holy Spirit (Luke 24:51). There are two angels

Photo: Allen Altchech

Figure 12.1. Mosaic Icon of the Ascension of Christ, from Saint Paul Greek Orthodox Church in Irvine, California

in the sky escorting the Lord into heaven, and between them there is another imaginary horizontal line, forming a cross with the vertical axis between Christ and Mary. It is through the Cross and His Resurrection that the Son of God now ascends to His glory "on the right hand of the power of God" (22:69).

According to Luke, while they were watching, Jesus was carried up into a cloud. As they gazed up toward heaven, suddenly two men wearing white appeared in their midst (Acts 1:10). Notice the difference in the angels in this icon. The two angels on earth are rendered as young men dressed in brilliant white. They are adorned in much the same way as the angels who proclaimed the good news of Christ's Resurrection: "He is risen! He is not here" (Mark 16:6) to the myrrh-bearing women at the empty tomb.[1]

The angels in heaven, however, are clothed in red, which here refers to many of the prophecies and visions of the Son of Man. The Prophet Isaiah, for example, envisions the Messiah with garments dyed red:

> Who is this who comes from Edom,
> With dyed garments from Bozrah,
> This One who is glorious in His apparel,
> Traveling in the greatness of His strength? . . .
> Why is Your apparel red,
> And Your garments like one who treads in the winepress?
> (Isa. 63:1–2)

John the Evangelist shares a remarkably similar vision of Christ in his Revelation: "He was clothed with a robe dipped in blood, and His name is called The Word of God" (Rev. 19:13).

The Twofer

The Ascension icon is something of a "twofer" (two for the price of one) because it is really two events in one. This icon presents another feature that seems very curious at first glance. First, it is helpful to understand that the designation of "Apostle" is given in Scripture only to those sent out by Christ to preach the good news, who also experienced the resurrected Christ: "And with great power the apostles gave witness to the resurrection of the Lord Jesus" (Acts 4:33).

1. See chap. 11 under the heading "The Myrrhbearing Women at the Empty Tomb."

Figure 12.2. Seventeenth-century Icon of the Ascension, from the Yaroslavl Art Museum in Russia

The Apostle shown in the red robe nearest Mary is Saint Paul. Paul (also called Saul[2]) became a witness to the resurrected Christ on the road to Damascus when Jesus came to him in a bright light,

2. "Then Saul, who also is called Paul, filled with the Holy Spirit . . ." (Acts 13:9).

calling, "Saul, Saul, why are you persecuting me?" (Acts 9:4). Although Paul is, therefore, appropriately designated as an Apostle since he encountered the resurrected Lord, it seems very curious on the surface that he would be shown in an event that the Acts account places at forty days after Christ's Resurrection. At that time, Saul was already gathering steam to persecute followers of Jesus. Luke reports that Saul consented to the stoning of the first Christian martyr, the deacon Stephen (7:58). Acts 9:1 begins with "Then Saul, still breathing threats and murder against the disciples of the Lord"

So why would an icon showing the Ascension of Christ forty days after His Resurrection include Paul at that time? The answer is found in what the two angels on the ground said to the Apostles: "Men of Galilee, why do you stand gazing up into heaven? This same Jesus, who was taken up from you into heaven, will so come in like manner as you saw Him go into heaven" (Acts 1:11). Jesus promised that He would return in glory: "I will come again and will receive you to Myself; that where I am, there you may be also" (John 14:3).

Therefore, the answer to the question "Why is Paul there?" is that the Ascension icon serves an important dual purpose: it is also the Icon of the *Parousia*, or Christ's Second Coming. Mary and the Apostles—including the later-believing Paul—represent the entire Church waiting for the Lord's return.

For Our Sake

Jesus was Resurrected for our sake and conquered death itself so that we can be "in the likeness of His resurrection" (Rom. 6:5). His Ascension, similarly, was for our sake. The place to which Jesus ascended was not for His benefit alone: "I go to prepare a place for you" (John 14:2). The icon shows that our created human form has been taken to a place of honor "standing at the right hand of God" (Acts 7:56). As with His Cross and Resurrection, Christ's Ascension was not individualistic. The Ascension was the inauguration of His communal invitation: "that you may eat and drink at My table in My kingdom" (Luke 22:30).

Fifty Days Later: The Descent of the Holy Spirit

The final icon for this book, the Descent of the Holy Spirit at Pentecost, is not technically an event described in one of the four Gospels of the New Testament. It is nevertheless anticipated in Saint Luke's Gospel, and described fully in the Acts of the Apostles, which in effect serves as part 2 of Luke's Gospel account. The event of Pentecost begins with the Apostles "with one accord in one place" when suddenly "there came a sound from heaven, as of a rushing mighty wind, and it filled the whole house where they were sitting" (Acts 2:1–2). There appeared "divided tongues, as of fire, and one sat upon each of them" (2:3).

They were all filled with the Holy Spirit and began to speak in other languages, so that the people from "every nation under heaven . . . heard them speak in his own language" (Acts 2:5–6). This is understood as God's reversal of the confusion of tongues at the Tower of Babel (see Gen. 11:1–9).[3] From this point forward, the diversity of languages will cease being a source of separation or confusion, and the gospel can henceforth be communicated through all tongues.

The descent of the Holy Spirit generated great excitement. Saint Luke reports that the sound brought "the multitude" to that place. Many were confused, and many were amazed and marveled (Acts 2:6–7) as they heard the Apostles "speaking in our own tongues the wonderful works of God" (2:11). Some observers did not understand and mocked the Apostles as being "full of new wine" (2:13).

Yet the Icon of Pentecost does not reflect anything resembling confusion or commotion, but serene harmony. Leonid Ouspensky explains that the icon is directed to the faithful. It does not intend to reflect what he calls the "general perturbation" of the event nor the perceptions of the "external, uninitiated people."[4] Instead, the

3. Per Gregory the Theologian (Nazianzus) on Pentecost: "But as the old Confusion of tongues was laudable, when men who were of one language in wickedness and impiety, even as some now venture to be, were building the Tower; (Genesis 11:7) for by the confusion of their language the unity of their intention was broken up, and their undertaking destroyed; so much more worthy of praise is the present miraculous one." "Oration 41," New Advent, https://www.newadvent.org/fathers/310241.htm.

4. Vladimir Lossky and Leonid Ouspensky, *The Meaning of Icons* (Crestwood, NY: St. Vladimir's Seminary Press, 1982), 207.

By the hand of Michael Kapeluck

Figure 12.3. Pentecost

icon reveals to the Church that which was revealed to those who experienced the gifts of the Holy Spirit—the inner meaning of the event: calm, solemnity, and harmony.

In every version of this icon, the Apostles are shown seated in a semicircle, usually with an unoccupied place at the head for Jesus Christ, Who is the Head of the Church. Even though Jesus is not visible, He is present in their midst since He promised to be present wherever two or three are gathered in His name (Matt. 18:20). Also, it was Jesus who initiated this gift, by asking His Father to send the Holy Spirit to abide with His followers forever (John 14:16, 26).

The structures in the back reflect the location, which is Jerusalem. The historical event takes place indoors, in the upper room of a house (Acts 1:13), as noted by the attribute of the red drape. The tongues of fire (2:3) are represented in various ways in iconography, yet always divided and individual. Some icons show flames directly over the head of each Apostle (as in the landscape version of the icon). Others show the dynamic nature of the indwelling of the Holy Spirit with tongues "as of fire" descending upon the Apostles (as in the portrait version of this icon). In each case, the divine source of these spiritual gifts is the Holy Trinity, represented by the semicircular vault that extends beyond the upper limits of the icon, with rays extending downward, conveying the fullness of divine action in this event.

The Apostles are rendered similar in size, as opposed to natural art in which those in the back would be shown smaller than those in the front. The semicircle format emphasizes equality and absence of hierarchy, yet the preeminent Apostles, Peter and Paul, are shown at the top and may appear slightly larger due to the use of inverse perspective.

As in the Icon of the Ascension, Paul would certainly not have been present in the upper room on the day of Pentecost, yet his presence in the icon speaks to his inclusion as an Apostle.[5] In fact, not all the twelve men here were members of the Twelve. In addition to the late-comer Paul, Luke the Evangelist and Mark the Evangelist are also included in this icon, as both were counted among the seventy

5. Paul correctly self-identifies as an Apostle of Christ (e.g., Rom. 1:1; 1 Cor. 1:1; Gal. 1:1) because he was a witness to the risen Lord on the road to Damascus and after his baptism was sent to preach that Jesus is the Son of God (Acts 9:1–22).

Figure 12.4. Descent of the Holy Spirit, by the hand of Dmitry Shkolnik, from Saint Paul Orthodox Church in Dayton, Ohio

Apostles sent out by Christ "two by two" to proclaim the good news (Luke 10:1, 17). This icon emphasizes the fulfillment of the prophecy of Joel (Acts 2:16–21) that the whole Church—not only the Twelve— will receive the gifts of the Holy Spirit.[6]

In both icons shown here, Paul is shown holding a book, emphasizing the importance of his written work in the New Testament. Other Apostles are holding books, Luke on the left side and Mark on the right side of the icon by the hand of Dmitry Shkolnik.[7] The icon by the hand of Michael Kapeluck includes Matthew on the left, holding a book. Some of the Apostles are shown holding scrolls, which are symbolic of the spiritual gifts they received on this day that enabled them to go out into the inhabited world proclaiming the gospel of Jesus Christ. The hands that are not holding something are rendered in a casual way, such as laid across a knee or gesturing as if the Apostles were conversing with one another.

6. Lossky and Ouspensky, *Meaning of Icons*, 208.
7. Versions of this icon are inconsistent as to the number of books shown, whether three, four, or even five.

The colors in this icon are vivid, expressing the joyful exuberance of the inauguration of the Church's mission in the fullness of the Holy Spirit. This gathering reflects an inner unity but not uniformity. Even the posture and gesture of each Apostle is unique—no two are exactly alike—reflecting the diversity of gifts given by the Holy Spirit. As Gregory the Theologian (of Nazianzus) writes, "For being poured from One Spirit upon many men, it brings them again into harmony. And there is a diversity of Gifts."[8] And of course Saint Paul will also later emphasize that "there are diversities of gifts, but the same Spirit" (1 Cor. 12:4). This also explains why the tongues of fire are shown as divided (Acts 2:3) and unique to each person.

The figure at the bottom is called "Cosmos," which simply means "universe" in Greek. He is not himself a negative figure but a symbolic figure representing the world that has been darkened by sin. A nineteenth-century Russian text explains that "he is bowed down with years, for he was made old by the sin of Adam; his red garment signifies the devil's blood sacrifices; the royal crown signifies sin, which rules in the world; the white cloth in his hands with the twelve scrolls means the twelve Apostles, who brought light to the whole world with their teaching."[9]

Although this is the final icon of the book, it marks a dramatic beginning. The Descent of the Holy Spirit at Pentecost empowers the Apostles to spread the gospel and inaugurates the Church and its life in the fullness of the Holy Spirit. Three thousand souls were baptized on that first day (Acts 2:41), and "the Lord added to the church daily those who were being saved" (2:47). Throughout the rest of the Acts of the Apostles, Luke takes great care to document how the gospel of Jesus began to spread like wildfire throughout the inhabited world, as it has even to the present day.

8. Gregory the Theologian, "Oration 41," New Advent, https://www.newadvent.org/fathers/310241.htm.

9. Nikolay Vasilievich Pokrovsky, *The Gospel in Monuments of Iconography* (St. Petersburg: Department of Udlot, 1892), 463, quoted in Lossky and Ouspensky, *Meaning of Icons*, 208.

EPILOGUE

My final thoughts are directed to those encountering Eastern Orthodox Christianity for the first time through these pages. If you find yourself intrigued by the way Scripture and Orthodox icons mutually illuminate and convey the same spiritual truths, I encourage you to explore further the rich harmony that permeates the Orthodox Church. Just as the icon serves as the visual gospel, the Liturgy is the gospel conveyed through worship. With over 212 verses from both the Old and New Testaments woven throughout the hymns and prayers of the **Divine Liturgy**,[1] Scripture becomes an event of communion and not merely a text to be read.

This harmony across diverse forms is the work of the Holy Spirit, "the living breath of the Church that makes Truth known."[2] Since the time of the Apostles, the Holy Spirit has revealed divine truth to the Church, expressed in various forms. Whether through painted icons, written Scripture, chanted hymns and prayers of the ancient Divine Liturgy, or the dogmatic teachings of the Seven Ecumenical Councils, these elements convey the same teachings without contradiction.

1. Kallistos Ware, *The Orthodox Way* (Crestwood, NY: St. Vladimir's Seminary Press, 1979), 89.
2. Vladimir Lossky, "Tradition and Traditions," in *In the Image and Likeness of God*, ed. John H. Erickson and Thomas E. Bird (Crestwood, NY: St. Vladimir's Seminary Press, 1974), 152.

Therefore, I invite you to continue your exploration of icons in their natural setting of worship, where the "living breath" of the Holy Spirit is also revealed through other dimensions of the Orthodox Faith. Whether you continue to delve deeper or simply carry these insights with you, I pray that your path of exploration always brings you to greater knowledge of Jesus Christ, "the true Light" Who gives His divine light to all (John 1:9).

SELECT BIBLIOGRAPHY

Baggley, John. *Festival Icons for the Christian Year*. Crestwood, NY: St. Vladimir's Seminary Press, 2000.

Constas, Fr. Maximos. *The Art of Seeing*. Alhambra, CA: Sebastian, 2014.

Crossan, John Dominic, and Sarah Sexton Crossan. *Resurrecting Easter: How the West Lost and the East Kept the Original Easter Vision*. New York: HarperCollins, 2018.

Evdokimov, Michael. *Light from the East: Icons in Liturgy and Prayer* (Mahwah, NJ: Paulist Press, 2004).

Evdokimov, Paul. *The Art of the Icon: A Theology of Beauty*. Translated by Fr. Steven Bigham. Redondo Beach, CA: Oakwood, 1990.

Forest, Jim. *Praying with Icons*. Maryknoll, NY: Orbis Books, 2008.

Hart, Aidan. *Beauty, Spirit, Matter: Icons in the Modern World*. Herefordshire, UK: Gracewing, 2014.

John of Damascus. *On the Divine Images*. Translated by David Anderson. Crestwood, NY: St. Vladimir's Seminary Press, 1980.

———. *Three Treatises on the Divine Images*. Translated by Andrew Louth. Crestwood, NY: St. Vladimir's Seminary Press, 2003.

Lossky, Vladimir, and Leonid Ouspensky. *The Meaning of Icons*. Crestwood, NY: St. Vladimir's Seminary Press, 1982.

Nes, Solrunn. *The Mystical Language of Icons*. Grand Rapids: Eerdmans, 2007.

———. *The Uncreated Light: An Iconographical Study of the Transfiguration in the Eastern Church*. Grand Rapids: Eerdmans, 2007.

Pelikan, Jaroslav. *Imago Dei: The Byzantine Apologia for Icons.* Princeton: Princeton University Press, 2011.

Vrame, Anton C. *The Educating Icon: Teaching Wisdom and Holiness in the Orthodox Way.* Brookline, MA: Holy Cross Orthodox Press, 1999.

Weissmann, Gilles. *Techniques of Traditional Icon Painting.* Kent, UK: Search Press, 2012.

GLOSSARY OF TERMS

altar: The area in the front of the physical Orthodox sanctuary, most often on the east end, separated from the congregation by the icon screen (iconostasis). The term also refers specifically to the altar table, on which is contained the Holy Gospel book and other articles blessed for exclusive use in liturgical worship.

ancestral sin: The falling away from God described in Genesis 3, which separated humankind from communion with God and resulted in an unnatural condition that led to our mortality. Other terms (such as "primal curse") are also used in Orthodox writings to refer to "the Fall." Jesus Christ has reversed the primal curse of humanity by His death and Resurrection, and Christians can be liberated from the curse through Baptism and the Holy Mysteries of the Church.

Annunciation: The "announcement" by the Archangel Gabriel to the Virgin Mary that she had been chosen to be the Mother of God (Luke 1:26–33). The Orthodox Great Feast of the Annunciation is celebrated on March 25, exactly nine months before Christmas, celebrated on December 25.

attribute: A characteristic or fixed symbol in an icon that consistently identifies a particular theme or person. For example, the wings

with which John the Baptist is sometimes depicted serve as an attribute that signifies his role as a "messenger" of God.

ax: An attribute or symbol of repentance shown at the lower left of the Icon of the Baptism of Christ. It is identified with the way in which John the Baptist enters the scene preaching repentance, warning that "the ax is laid to the root of the trees" (Matt. 3:10; Luke 3:9).

betrothed/betrothal: The first of two stages of marriage in ancient Jewish culture. It was a binding legal agreement between the couple and their families. The second stage was the actual marriage, marked by physical consummation. Once consummated, the betrothed couple was considered married.

Byzantine Empire: The Eastern Roman Empire, whose capital was established in Constantinople (now Istanbul) by Constantine the Great in AD 331. The Byzantine Empire was one of the greatest civilizations in history and one of the earliest Christian states. It was a dynamic center of culture and religious thought until 1453, when it was invaded and conquered by the army of the Ottoman Turkish Empire.

Chrismation: The Holy Mystery (sacrament) of anointing, which usually follows Baptism. Chrismation imparts to the candidate the "seal of the gift of the Holy Spirit," enabling the candidate to follow Christ throughout his or her life as a disciple. The counterpart in the New Testament is the "laying on of the apostles' hands" after Baptism (Acts 8:18). The nearest counterpart in Western Christian traditions is Confirmation, which often follows a course of catechetical instruction. Unlike in the practice of Confirmation in the West, there is no academic component in the practice of Orthodox Chrismation, since it is considered to be a free gift of the Holy Spirit and is normally bestowed in conjunction with Baptism.

Christ (Greek: *Christos*, "the Anointed One"): The Messiah (which is Hebrew for "the Anointed One"). Jesus Christ is the Anointed

One of God, anointed by the Holy Spirit by the will of the Father. This term indicates that both the Father and the Spirit actively participate in the ministry of Jesus. Christians are named *Christians* because those who are "in Christ" participate through Christ in the divine life of the Trinity and are anointed by the Holy Spirit in Baptism and Chrismation.

Christological: The dogmas related to the proper understanding of Christ (as opposed to heresy or error). A Christological teaching would be the affirmation of the divinity of Jesus Christ from the first Council at Nicaea in AD 325, and the later affirmation of the union of His two natures as inseparably fully God and fully human at the Fourth Council at Chalcedon in AD 451.

Church Slavonic: The ecclesiastical language for worship, prayers, and religious texts of the Slavic-speaking Orthodox churches, such as in Serbia, Romania, and Russia.

Divine Liturgy (Greek: *leitourgia*, "the work of the people"): The main worship service of the Orthodox Church at which the **Eucharist** is celebrated.

dual representation: The technique in Orthodox Christian iconography where Jesus is depicted in multiple scenes within a single icon. This approach is commonly used to convey various aspects of a biblical event or narrative, allowing viewers to contemplate the fullness of the story. It is often used in icons depicting the Nativity, the Transfiguration, and the Feeding of the Five Thousand, versions of which are shown in this book.

economy: Derived from the Greek *oikonomia*, meaning "house" (*oikos*) and "law" (*nomos*), in reference to God's administration or management of His divine plan within history. It encompasses how God arranges and dispenses His plan of salvation in Jesus Christ, such as in Ephesians 3:9.

Ecumenical Council: A worldwide assembly of bishops, convened under the guidance of the Holy Spirit in order to settle administrative or doctrinal disputes, and subsequently recognized as

having declared authoritative dogma for the entire Church. The main intention of the Seven Ecumenical Councils was to avoid theological error, not to establish a criterion of truth external to the Spirit of truth (John 15:26; 16:13). A council must be accepted by the entire Church to be considered "ecumenical" by the Orthodox Church. The seven councils accepted as ecumenical by the Orthodox Church are Nicaea I (AD 325), Constantinople I (381), Ephesus (431), Chalcedon (451), Constantinople II (553), Constantinople III (680–81), and Nicaea II (787).

eidōlon (Greek: "idol"): A false image. God commanded Moses not to make a carved *eidōlon* and worship it (Exod. 20:4).

Evil One: A comprehensive term used to describe the various ways the devil is identified in Scripture, embodying the source and personification of evil.

exegesis/exegetical: A careful analysis and interpretation of a text, particularly sacred Scripture, to understand meaning and context. In Orthodox Christianity, exegesis may also extend to the interpretation of icons, where symbols, colors, and figures are analyzed to reveal the theological insights and spiritual truths they convey.

feast day: An Orthodox celebration dedicated to commemorating significant events in the life of Jesus Christ, the Virgin Mary, or the saints, marked by worship, prayer, and community gatherings. Feast days are central to the Orthodox Christian liturgical calendar and are designed to deepen the faith of believers as opportunities for spiritual reflection, renewal, and joy. Some of the most important feast days include Christmas (the Nativity of Christ), the Baptism of Christ (Theophany), Easter (Pascha, the Resurrection of Christ), Christ's Ascension, and Pentecost.

fresco(es): A mural or Orthodox icon painted on a wall, for example, as opposed to being carved or created with mosaics.

Gnosticism (Greek: *gnōsis*, "knowledge"): A broad category of heretical teachings holding that Jesus gave secret knowledge to only a

select few, who handed down their secret knowledge to a select few in the next generation. Gnostics also usually follow the Platonic view that all matter is corrupt, thus denying the scriptural witness that God became human, died, and resurrected bodily. The Church has always taught that matter is good, because God created it and said that it was good (Gen. 1:31), and that Jesus Christ is not only fully God but also fully human (John 1; 1 John 1).

gospel: Literally "good news" (Greek: *euangelion*). For example, "Repent, and believe in the gospel" (Mark 1:15). The life of the Church is centered in the Good News that Jesus Christ is God incarnate, Who dwells among His people, the Church, through the power of the Holy Spirit.

grace: In Orthodox Christianity, grace is the uncreated glory of God, bestowed as a free and unmerited gift. It is the life and power that flows from God eternally and cannot be earned by human effort. Experiencing the grace of God is a direct encounter with God's presence, allowing for participation in the divine nature (2 Pet. 1:4).

Hades: The Greek equivalent to the Hebrew *Sheol*, which in Scripture is the place of the dead. The Orthodox Icon of the Resurrection shows Christ liberating the dead imprisoned in Hades, having bound the Evil One in chains (1 Pet. 3:18–20).

halo: A luminous, circular crown surrounding the head of Jesus Christ and righteous figures in Orthodox Christian icons, showing especially that the person has been transfigured by the Holy Spirit, reflecting their close relationship with God and their participation in His divine light.

heavenly vault: See **vault**.

hermeneutic: A theory or method of interpretation, used to understand the meaning of texts, symbols, or images, particularly within a religious context.

hierarchical perspective: The technique that uses larger size or central placement (or both) to emphasize the spiritual significance of subjects in an icon.

holy image(s): Another word for icon. "Holy Image" is often used in the same context as "Holy Scripture," as a visual (rather than contextual) form of the Holy Spirit's revelation to the Church.

hypostatic union (or **unity**): The term coined by Cyril of Alexandria in the fourth century to describe the genuine unity of the two perfect natures of Christ, which cannot be broken or destroyed, even in death. This term would become the definitive terminology of the undivided Church after the Fourth Ecumenical Council at Chalcedon (AD 451).

icon (Greek: *eikōn*, "true image"): A visual portrayal of Jesus Christ or a saint, or of a biblical event in the life of Christ. Icons are usually created with egg tempera paint on wood or with mosaic. Orthodox Christians venerate the Holy Icons but do not worship them, since worship is offered only to God. The Seventh Ecumenical Council declared that Holy Icons should be honored in the same way as the four Gospels, since both are witnesses to the truth of the gospel message and there is a complete correspondence between the verbal message of the Gospels and the visual image of the Holy Icons. The first reference to *eikona*/icon in the Bible is found in Genesis 1:26–27. Jesus is called the "*eikōn* of the invisible God" by Saint Paul (Col. 1:15).

iconoclast: Literally "icon smasher." See **Iconoclast Controversy**.

Iconoclast Controversy: The Iconoclast Controversy was a significant period of theological and political conflict within the undivided Christian Church that began in the early eighth century and continued for nearly one hundred and fifty years. It centered on the use and veneration of icons in worship, with iconoclasts opposing their use on the grounds that they constituted idolatry, while iconodules defended them as essential to Christian devotion and teaching because of the material nature of Christ's Incarnation. The controversy was ultimately resolved at the Seventh Ecumenical Council, also known as the Second Council of Nicaea, in 787, which affirmed the veneration of icons as being compatible with

Christian beliefs and practices, emphasizing that honor shown to icons passes to their prototypes. The resolution of the Iconoclast Controversy solidified the use of icons as an integral part of the undivided Church's worship and theology.

iconodule (literally "icon servants" in Greek): A supporter or advocate of the veneration of Orthodox icons. Iconodules uphold and defend the practice of honoring icons as an essential aspect of Christian worship and tradition. See **Iconoclast Controversy**.

iconographer: Literally "image writer." The iconographer is a member of the Orthodox Church who creates icons according to canonically defined styles. While typically using paint, icons can also be created in mosaic or by carving. Orthodox iconographers are trained in ancient techniques and adhere to strict conventions in order to preserve the continuity of the iconographic tradition. They approach their work with prayer and reverence in order for their work to reflect that which is theologically accurate and spiritually illuminating.

iconographic: That which is related to Orthodox icons, characterized by a particular canonical style of visual representation of events and figures in the Christian tradition.

iconography: The sacred art of depicting religious subjects through visual form, such as icons. Guided by specific traditional principles, iconography aims to convey spiritual truths and biblical teachings in a way that maintains continuity with the Church's theological and liturgical heritage.

iconophile ("icon lovers" in Greek): See **iconodule** and **Iconoclast Controversy**.

iconostasis: See **icon screen**.

icon screen: The wall or partition in an Orthodox church that separates the altar from the nave. It is adorned with icons of Jesus Christ, the Archangels, Saints, and events from Scripture.

icon of God (Greek: *eikona tou theou*): According to Genesis 1:26–27, human beings were created in the image of God according to the

likeness of God. The image of God is ascribed only to human creation and asserts a potential similitude to, and participation in, the divine life. The Orthodox Church teaches that although the image of God has become tarnished by sin, it has not been destroyed. By His Incarnation, Jesus Christ restored the image of God, thus enabling human nature to be returned to its original beauty. The image of God is renewed through Baptism by the grace of the Holy Spirit (2 Cor. 3:18).

immaterial: Without form or substance, not made up of created matter.

incarnate (from Latin: to be "en-fleshed" or "in-fleshed"): Having taken on flesh or "become flesh." In the Incarnation, the Son of God took on flesh (John 1:14) and became fully human yet remained fully God.

incense: An aromatic plant substance, dried and burned in honor of God. God commanded Moses to make incense from myrrh, frankincense, and other aromatics and to burn it as an offering to the Lord in the holy of holies (Exod. 30:34–38). Malachi the prophet declares that even the Gentiles will offer incense in God's name (Mal. 1:11). Incense accompanies the prayers of the saints rising up (Ps. 141:2 [140:2 LXX]; Rev. 5:8; 8:4). It is still used in the context of Orthodox worship today.

inverse perspective: The technique present in every Orthodox icon, in which size and positioning of elements or figures are not determined by the natural way the eye perceives depth and dimension in flat images. Unlike in natural perspective, where objects closer to the viewer are shown as larger and objects farther away are smaller, inverse perspective emphasizes the spiritual significance of subjects over physical realism. This approach may result in figures and objects appearing larger or more prominent based on their spiritual importance rather than on their spatial position.

kenosis: The self-emptying of Jesus Christ in His incarnation, derived from the Greek word for "emptying." It describes the process by

which Christ voluntarily left His heavenly throne and took on human form, embodying humility and servitude as described in Philippians 2:7.

Kingdom of God: The coming of Jesus Christ inaugurated God's Kingdom on earth, which is now present to the faithful through His Church. The Orthodox Divine Liturgy opens with the words, "Blessed is the Kingdom of the Father and of the Son and of the Holy Spirit, both now and forever and to the ages of ages. Amen," testifying to the Orthodox understanding of eucharistic worship as a participation in the eternal Kingdom of God. Jesus Christ will return again to usher in the fullness of God's Kingdom (Rev. 12:10).

magi: The men who came from the east to worship the Christ Child (Matt. 2:1–12). The magi were thought to be astrologers and sorcerers from a Median and Persian priestly caste. The term "magi" in Greek shares the same root as "magic."

mandorla: From the Latin word meaning "almond," an element in icons that is usually almond shaped, dark in the center, with bright rays extending outward. Christ is rendered in certain icons as standing in front of the mandorla, the rays of which represent His uncreated glory reaching out into the created universe.

motif: A recurring theme or element in Orthodox iconography that conveys a significant theological or spiritual concept. Motifs are used to express core aspects of the faith and provide continuity across different icons.

myrrhbearers/myrrhbearing women: The women who came to the tomb of Jesus Christ on the morning after the Sabbath day to anoint His body. These women are called "myrrhbearers" because they brought myrrh and spices to anoint the body of Jesus Christ after His death (Luke 24:1, Mark 16:1). The Holy Myrrhbearers are formally honored as "Equal to the Apostles" in the Orthodox Church and commemorated on the Sunday after Pascha.

nimbus: A circle of radiant light or glory, such as a halo surrounding the head of a righteous person.

Pantocrator (literally "almighty" or "all-powerful" in Greek): The Pantocrator Icon is a representation of Jesus Christ, the Almighty Ruler and Judge of the universe. In Orthodox Christian churches, the Pantocrator Icon is typically placed in the central dome or high above the altar, symbolizing Christ's divine authority and presence. This icon serves as a reminder of Christ's sovereign rule over all creation and invites the faithful to enter into heavenly worship, participating in the eternal liturgy of the angels and saints and acknowledging Christ as the center of all spiritual life and worship.

paradox/paradoxical: A statement or concept that appears contradictory or beyond human logic but is true within the context of faith. In Orthodox Christianity, paradoxes often express the mysteries of divine truth that transcend human understanding. Examples include the doctrine of the Holy Trinity, where God is both one and three, and the virgin birth of Jesus Christ, where Mary remains a virgin while giving birth to the Son of God.

parousia: The second coming of Jesus Christ. In Greek, *parousia* means "presence" and more specifically "presence after absence." Early Christian writers, such as Ignatius of Antioch, referred to Christ's Incarnation as His "first parousia" (*Epistle to the Philadelphians* 9.2). Typically *parousia* without qualification refers to Christ's return in glory or "second coming" and "the end of the age" (Matt. 24:3). The word *parousia* is found in the New Testament in verses such as Matthew 24:3, 1 Corinthians 15:23, and 1 Thessalonians 2:19.

Pascha (Greek for "Passover"): The Orthodox term for Easter, the Resurrection of Christ. Pascha is the "Feast of Feasts" and the focus of the Orthodox Christian life. The Jews who were enslaved in Egypt were told to mark their doors with the blood of the Passover lamb and were thus delivered from death (Exod. 12:12–13). Jesus Christ is the pure Lamb of God Whose blood

on the Cross allows us to pass from death to life (1 Cor. 5:7–8). Orthodox Christians celebrate Pascha after the Jewish Passover has begun, and thus Pascha can be one or more weeks after the Roman Catholic and Protestant Easter.

Pentecost: The Orthodox Christian Great Feast that commemorates the descent of the Holy Spirit on the Apostles fifty days after the Resurrection of Christ (Acts 2). The event of Pentecost is considered to be the formal inauguration of the Church by the Holy Spirit—the day on which the Church established by Jesus Christ was given new warmth and power by the indwelling of the Holy Spirit to make it grow and spread throughout the inhabited earth.

pericope (Greek for "cutting around"): A short passage from Scripture that describes an event or conveys a coherent unit of thought.

red drape: Used in Orthodox iconography to indicate that a biblical event is taking place indoors, since there are no walls, light sources, or shadows in iconography to suggest an interior setting. The purpose of an icon is to transcend created time and space. However, biblical events depicted in icons are grounded in specific physical, historical contexts. The red drape serves as a symbolic reference to the natural, time-bound setting of the event (such as an indoor location) while extending its meaning into the eternal realm. This approach reflects the Orthodox belief that icons are windows to the divine, connecting the temporal world with the eternal truth of God's presence and action.

repentance (Greek: *metanoia*, "change of mind" or "change of attitude"): A sorrowful recognition of one's sinful behavior that results in a turning away from that behavior and toward a life of righteousness in Christ.

Resurrection: Rising from the dead. Resurrection refers specifically to Jesus Christ's victory over death through His own death and His subsequent rising. By His Resurrection, Christ not only conquered death but also opened the way for all humanity to experience renewed and eternal life. The Resurrection is celebrated on

Easter, called Pascha or the "Feast of Feasts" in the Orthodox Church, and is commemorated with great joy and reverence.

Septuagint: An ancient Greek translation of the Hebrew Bible from between the third and first centuries BC. The Septuagint Greek Old Testament text is the version most often quoted by Jesus and the authors of the New Testament.

symbol: An attribute or element in Orthodox Christian iconography that conveys a specific, fixed meaning, often communicating theological truths or spiritual insights. For example, the ax depicted in the Icon of the Baptism of Christ near John the Forerunner and Baptist is a symbol of the message of repentance preached by John, as he warned that "even now the ax is laid to the root of the trees" (Matt. 3:10), urging people to turn from sin.

synergy: Derived from the Greek word meaning "working together," synergy refers to the process of salvation in which Christians actively cooperate with the Holy Spirit to conform their will with the Father's will in Jesus Christ (Rom. 8:28; 2 Cor. 6:1). While we can do nothing without God's help, believers are called to be "fellow workers" (Greek: *synergoi*) with God (1 Cor. 3:9).

Synoptic Gospels: Synoptic literally means "seen together" in Greek (*syn* = together, and *opsis* = seeing). The first three Gospel books—Matthew, Mark, and Luke—can be seen together, since they share descriptions of many of the same events in the life of Christ, often in the same order.

telos: Greek, meaning completion of purpose, or fulfillment.

tessera: A small individual tile—usually glass, stone, or ceramic—used in the creation of mosaics. Tesserae (plural) are arranged to form images, patterns, and scenes, such as in Orthodox Christian iconography.

tetragrammaton: The four letters used as shorthand for the biblical name of God in the Hebrew Bible. Israel's tetragrammaton for God is YHWH. The Orthodox Christian tetragrammaton for

Jesus Christ is ICXC, which is the first and last initials of the Greek words for Jesus Christ (Ἰησούς Χριστός).

theophany: Literally "God-appearance" in Greek (*Theos* = God, and *phaneia* = appear). A theophany is a visible manifestation or appearance of God. The Baptism of Christ in the Jordan is called the Feast of Theophany in the Orthodox Church because the Holy Trinity, Father, Son, and Holy Spirit, were fully manifested upon the earth.

transcendent: A term that describes the nature of God as existing prior to, beyond, and independent of the physical universe, indicating that the essence of God's inner life as Trinity is also beyond the limits of human comprehension.

Transfiguration (Greek: *Metamorphōsis*): A complete change in form and appearance. Jesus was transfigured on Mount Tabor when His face and clothes became dazzlingly bright and His three disciples perceived His divine glory (Matt. 17:1–13; Mark 9:2–13; Luke 9:28–36). The term also signifies a transformation in the created world resulting from the Son of God's entry into creation, aimed at renewing and redeeming it.

troparion: A hymn that summarizes succinctly a feast or the life of a saint of the Church being commemorated.

uncircumscribable: An adjective that in Latin literally means the inability (un + able) to write or draw (scribe) a circle (circum) around God. The understanding is that nothing fits around God because God is the Creator of all things, without limits, and beyond all things.

uncreated glory: The divine quality and essence of God's glory, which underscores the fundamental distinction between the Creator and His creation. Unlike created entities that have a beginning and an end, God's uncreated glory is eternal and infinite. It embodies the fullness of God's eternal being and is not a product of creation. Believers can experience God's love, mercy, majesty, and perfection through grace, allowing them

to perceive, to a limited degree, the infinite and transcendent nature of God's glory.

undivided Church: The one Christian Church before the Great Schism of 1054 AD. After this date, the See of Rome becomes the Roman Catholic Church, and the ancient Orthodox Sees of the Greek-speaking East (Jerusalem, Alexandria, Antioch, Constantinople) continue into the present day as the Orthodox Church.

vanishing point: The point in a perspective drawing where parallel lines appear to converge, creating the illusion of depth and distance. In naturalistic art, this point is typically where lines recede toward the horizon at the back of the image. In Orthodox Icons, the vanishing point may proceed forward toward the viewer, emphasizing a different spatial perspective.

vault: Since God the Father is immaterial (has no form) and thus cannot be portrayed in icons, the participation of the Father in a biblical event is symbolized by the semicircular shape at the top of certain icons. Rays also extend from the heavenly vault and represent the uncreated glory of God. Icons shown in this book that include the heavenly vault are the Annunciation to Mary, the Nativity of Christ, the Baptism of Christ, and Pentecost.

venerate: To show deep respect, honor, or reverence for someone or something. Unlike worship, which is reserved for God, veneration involves acts of respect such as bowing, kissing, or praising. In Orthodox Christianity, veneration is given to Holy Icons and the Book of the Gospels because they convey the truth of Christ. Orthodox Christians also venerate the Virgin Mary and other saints, acknowledging God's work in and through them and honoring their devotion to Christ.

INDEX

Note: Bold page numbers refer to icon images.